BEST LOVED

Favourite Poems from the South of Ireland

POEMS

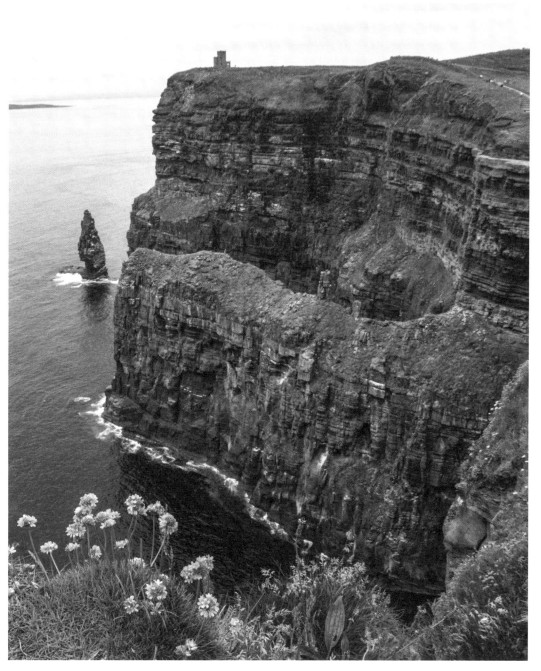

The world famous Cliffs of Moher.

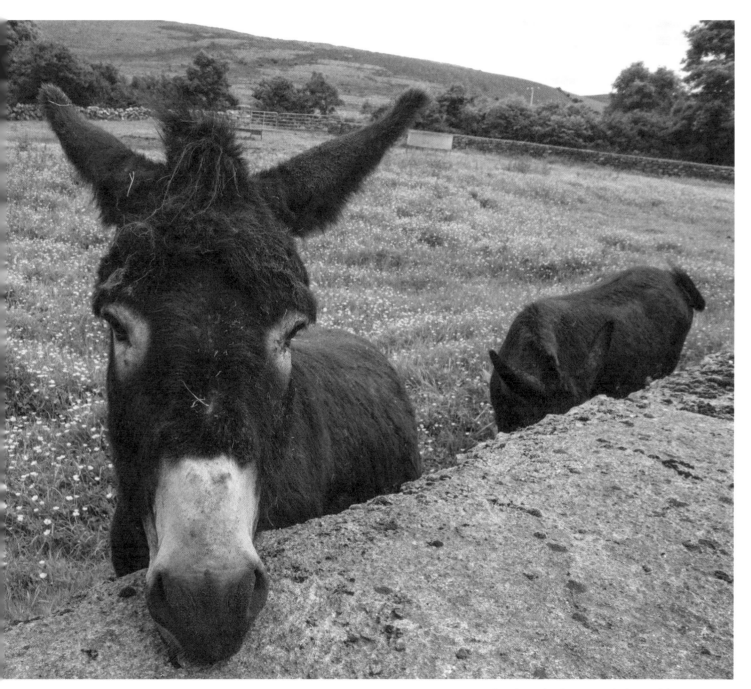

Rich pickings for this pair in the heart of the Burren.

First published in 2016 by Currach Press

23 Merrion Square

Dublin 2

Ireland

www.currach.ie

With kind support from the Kerry County Council Arts Office.

ISBN: 978-1-78218-890-2

Set in Adobe Garamond Pro 10.5/15 and Gill Sans

Book design by Helene Pertl | Currach Press

Printed with Jellyfish Solutions

Front cover: Cummeengeera from the Rabach's Glen on the Kerry side of the Ring of Beara.

Back cover: Back window of the house of Sliabh Luachra musical genius, Patrick O'Keeffe (1887–1963), Glounthane, Cordal.

BEST LOVED

Favourite Poems from the South of Ireland

POEMS

Edited by GABRIEL FITZMAURICE
Photography by JOHN REIDY

CURRACH PRESS · DUBLIN

For Jim and Linda Kennelly

GF

Dedicated to my mentors:
Kevin Coleman, Donal, Don, Harry and Philip MacMonagle,
Seamus McConville, Ger Colleran, John Barry, Michael Healy.

JR

CONTENTS

Opposite: The beauty of Glengariff.

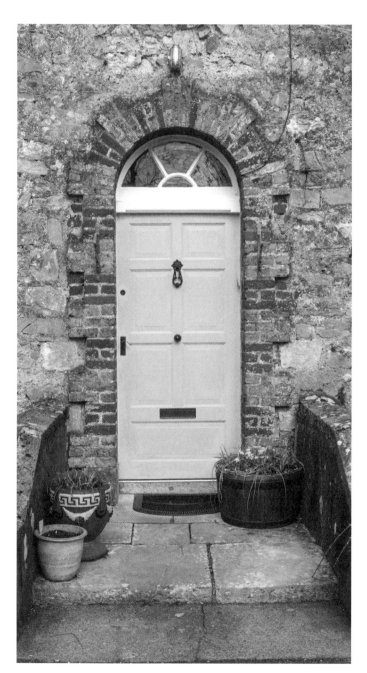

An attractive door on King Square in Mitchelstown.

A black-faced sheep at the entrance to the Black Valley.

Busy Ballybunion on the Shannon Estuary.

Gabriel Fitzmaurice

INTRODUCTION

'Favourite Poems from the South of Ireland'. For 'the South of Ireland' read the province of Munster – counties Kerry, Cork, Limerick, Tipperary, Clare and Waterford. It is necessary to point out that this book collects favourite poems – favourite poems of mine originally written in Irish and English, poems that have proved popular favourites with the general reader as well as with the poetry reading public, poems that have stood the test of the centuries, and popular songs and ballads.

The province of Munster has produced many fine poets, women and men, down through the centuries and there have been a number of anthologies of Munster poetry that have set out to be canonical. This is not one of them. This anthology contains some of the best poetry written by poets born, or brought up, in Munster since the ninth century. I hope it brings as much pleasure to the reader as compiling it brought to me.

This book contains many of the passions and obsessions not just of Munster women and men but passions and obsessions that are universal. It sings of love and death, poetry, song and language, and politics – the Irish Civil War of 1922–1923 and the betrayal of the new republic where, as our President Michael D. Higgins writes in his poem, 'the new State/was a good thing,/even for business'. In this book you will find poems of religion and spirituality, of faith and doubt; there are poems about fathers and mothers and their children. There is a large number of poems about women that were originally written in Irish as well as English, for instance the ninth century 'The Old Woman of Beare' translated by Brendan Kennelly, Eibhlín Dhubh Ní Chonaill's 'The Howl for Art Ó Laoghaire' from the eighteenth century translated here by Paddy Bushe, 'The Midnight Court' written also in the eighteenth century by Brian Merriman and translated by Frank O'Connor, 'The Madwoman of Cork', possibly Patrick Galvin's most famous poem, 'The Keener' by Eugene O'Connell and Michael Hartnett's much celebrated 'Death of an Irishwoman'. There are cursing poems and homages to our native games of Gaelic football and hurling. There are poems of poverty and emigration.

I have included poems by nationally and internationally celebrated Munster poets as well as favourite poems from the younger generation who are continuing the ancient tradition of Munster poetry in Irish and English. Apropos the Irish language, which is still spoken from the cradle in parts of the province, I would have loved to have included the original Irish poems along with their English translations but, as I was caught for space, I very reluctantly decided to represent them with English translations only thus enabling me to include more Irish poems.

In compiling this anthology, I wanted, among other things, to trace the journey from the beginning of poetic expression which comes, in the words of Brendan Kennelly:

> Afraid of insufficient self-content,
> Or some inherent weakness in itself,
> Small and hesitant,
> Like children at the tops of stairs …
> [T]hrough shops, rooms, temples,
> Streets, places that were badly-lit

to its happy conclusion in Desmond O'Grady's marvellous 'Tipperary' ('from the Irish *Tiobraidarann*: the fountain of perception, or enlightenment, intelligence'), where

> … when you get there
> nothing awaits you. You'll find no roadsign,
> no brassband and welcoming committee
> with a banner proclaiming you're in Tipperary
> and a medallion to hang around your neck.
> You'll find only what you brought with you
> in your heart.
>
> Then, what you must do
> is make and leave some record
> of what your Tipperary means to you –
> as witness for all those behind you
> on their ways to their own Tipperaries.

The danger of compiling any anthology is that the anthologist cannot please everybody – the critics will point to poets who had to be left out and will rubbish some who got in; the poets who were excluded will curse the anthologist and so on. I took on the job because I thought that it was one worth doing. I have done it fairly and honestly, making a generous selection of poets, women and men, languages, Irish and English, and themes within the space allotted to me. As the poet, ballad maker, short story writer, novelist, playwright and translator, the late Bryan MacMahon of Listowel in County Kerry used to pronounce when he had completed something worth doing – 'something done'. And so say I: something done. Enjoy!

Gabriel Fitzmaurice
Good Friday, 25 March 2016

A sign of other times in Clogheen, Co. Tipperary.

BIOGRAPHICAL NOTES

Gabriel Fitzmaurice

Gabriel Fitzmaurice was born, in 1952, in the village of Moyvane, Co. Kerry where he still lives. For over thirty years he taught in the local primary school from which he retired as principal in 2007. He is author of more than fifty books, including collections of poetry in English and Irish as well as several collections of verse for children. He has translated extensively from Irish and has edited a number of anthologies of poetry in English and Irish. He has published two volumes of essays and collections of songs and ballads. Poems of his have been set to music and recorded by Brian Kennedy and performed by the RTÉ Cór na nÓg with the RTÉ National Symphony Orchestra. He frequently broadcasts on radio and television on education and the arts.

He has been described as 'the best contemporary, traditional, popular poet in English' in *Booklist (U.S.)*, 'a wonderful poet' in the *Guardian*, 'one of Ireland's leading poets' in *Books Ireland*, 'Ireland's favourite poet for children' in *Best Books!* and 'the Irish A. A. Milne' by Declan Kiberd in the *Sunday Tribune*.

John Reidy

John Reidy was born in Castle Island* in 1953 and has been covering his native Co. Kerry as a newspaper photographer for the past three and a half decades. Athletes, elections, floods, fights, local and visiting politicians, heads of state, porter drinkers, pilgrims, pioneers, poets and potholers have all come into focus in the eyepiece of his cameras over the years. While John contributes a weekly column of news and photographs to a local newspaper he has recently developed an online news website, The Maine Valley Post. It can be found at: www.mainevalleypost.com

John is married to Cathleen and they have a son, Micheál. Micheál and his wife Kathy live in Salthill in Galway and have given John and Cathleen two wonderful grandchildren, Cate (5) and Seán (18 months – almost).

*'Castle Island' in deference to an outstanding native, Con Houlihan (1925–2012)

Tree-lined avenue to the historic Vandeleur Estate in Kilrush.

Rosita Boland was born in County Clare in 1965. She is widely published in anthologies including *Pillars of the House* (Wolfhound Press) and *Hard Lines 3* (Faber). Her first collection, *Muscle Creek*, was published by Raven Arts Press, Dublin, in 1991.

Sigerson Clifford (1913–1985), poet, short story writer and playwright was born Edward Bernard Clifford in Cork, the 'Sigerson' being his mother's maiden name. *Ballads of a Bogman* was first published by Macmillan in 1955 and an expanded edition was reprinted in 1986 by Mercier Press, Cork.

Michael Coady was born in 1939 in Carrick-on-Suir, County Tipperary where he still lives. He won the 1979 Patrick Kavanagh Award for poetry. Since his first book, *Two for a Woman, Three for a Man*, was published in 1980, he has published several collections with Gallery Press.

Tim Cunningham was born in 1942 in Limerick. Educated at CBS Limerick and Birbeck College, London, he has worked with a brewery, the National Coal Board and in teaching. His poetry collections have been published by Peterloo Poets, Cornwall, and Revival Press, Limerick.

Pádraig J. Daly was born in Dungarvan, County Waterford in 1943. An Augustinian friar, he was educated at University College, Dublin and the Gregorian University in Rome. He has published several collections of poetry, most recently with Dedalus Press, Dublin.

Michael Davitt (1950–2005) was born in Cork and was educated at the North Monastery there and at University College, Cork where he founded *INNTI*, the groundbreaking Irish language poetry magazine in 1970. He was influenced by Seán Ó Ríordáin and the American Beat Poets.

Greg Delanty was born in 1958 in Cork and educated at University College, Cork. He lectured at Saint Michael's College, Vermont. He won the Patrick Kavanagh Award for poetry in 1983.

Theo Dorgan was born in Cork in 1953 and was educated at University College, Cork. A former Director of Poetry Ireland/ Éigse Éireann, he edited, with Gene Lambert, *The Great Book of Ireland* (1991). Since his first collection, *The Ordinary House of Love*, was published in 1990 by Salmon Poetry he has published many more collections, notably with Dedalus Press.

Seán Dunne (1956–1995) was born in Waterford and educated at University College, Cork. He worked as a journalist, becoming literary editor of the *Cork Examiner* newspaper. He published collections of his poetry with Dolmen Press and with Gallery Press.

Gabriel Fitzmaurice (see above).

Patrick Galvin (1927–2011), poet and dramatist, was born in Cork. He left school at about eleven years and worked in a variety of jobs. He went to Belfast in 1943 and joined the Royal Air Force. His *New and Selected Poems*, edited by Greg Delanty and Robert Welch, was published by Cork University Press in 1996.

Michael Hartnett (1941–1999) was born in Croom, County Limerick and educated in Newcastlewest where he lived. His first book, *Anatomy of a Cliché*, was published by Dolmen Press in 1968. In 1975 he published his *A Farewell to English*, and for a number of years thereafter wrote and published mainly in Irish, returning to English when he moved to Dublin again in 1985.

Michael D. Higgins, poet, politician and currently President of the Irish Republic, was born in Limerick in 1941 and reared on a small farm in County Clare. He was Minister for Arts, Culture and the *Gaeltacht* in the two coalition governments between 1992 and 1997. His *New and Selected Poems* were published by Liberties Press, Dublin, in 2011.

John B. Keane (1928–2002) was born in Listowel, County Kerry and was educated locally in Saint Michael's College before emigrating to England where he worked at various jobs and began to write. Undoubtedly Ireland's most popular playwright, he published *The Street*, a book of poems in 1961. An expanded edition was published by Mercier Press, Cork, in 2003.

Brendan Kennelly was born in Ballylongford, County Kerry in 1936. He was educated in the local national school, in the nearby Saint Ita's secondary school, Tarbert, at Trinity College, Dublin and at the University of Leeds. He became a professor at Trinity College, Dublin, in 1973. A prolific and hugely popular poet, he has published versions of classical texts *Antigone*, *Medea* and *The Trojan Women* as well as translations from Irish.

Charles J. Kickham (1828–1882), novelist, poet and rebel, was born near Mullinahone, County Tipperary. A strong supporter of the Young Ireland movement, he became a Fenian in 1860. As well as novels and poems, he wrote lyrics for many still current popular songs.

John McAuliffe, born in 1973, grew up in Listowel, County Kerry where he was educated at Saint Michael's College. He co-directs the Centre for New Writing at the University of Manchester where he edits *The Manchester Review.* He writes the regular poetry column in *The Irish Times.*

Thomas McCarthy was born in 1954 in Cappoquin, County Waterford. He was educated at University College, Cork. A poet and novelist and winner of the 1977 Patrick Kavanagh Poetry Award, his first collection, *The First Convention*, was published in 1978 by Dolmen Press. He now publishes with Anvil Press, London.

Thomas MacGreevy (1893–1967) was born in Tarbert, County Kerry. He served as an artillery officer in the First World War and entered Trinity College, Dublin on his return. A friend in Paris of James Joyce and Samuel Beckett, he published his only collection of poetry, *Poems*, in London and New York in 1934.

Bryan MacMahon (1909–1998), poet, ballad maker, playwright, writer of fiction and translator, was born in Listowel, County Kerry where he lived all his life and taught in the local national school. He had a deep understanding of Irish travellers and spoke Shelta, their secret language.

Brian Merriman (1745?–1805) was born near Ennistymon, County Clare. He taught in the local school in Feakle, County Clare where he wrote his celebrated long poem, *Cúirt an Mheán-Oíche* (The Midnight Court), about 1780 before moving to Limerick city about 1802 where he started a school of mathematics.

William Pembroke Mulchinock was born in 1820 in Tralee, County Kerry. He emigrated to America in 1849 remaining there until 1855. While there, he published, in 1851, a book of poems which he dedicated to the poet Longfellow. *The Rose of Tralee* is taken from that collection. He returned to Ireland in 1855 and died in Tralee in 1864.

Eibhlín Dhubh Ní Chonaill (*c.*1743–*c.*1800) was born in Derrynane, County Kerry. She was an aunt of Daniel O'Connell, the Liberator. The verses of her 'howl' for her husband, Art Ó Laoghaire, spoken in Irish, were written down years after they were first uttered after his death on 4 May 1773.

Eiléan Ní Chuileannáin was born in Cork in 1942. She was educated at University College, Cork and at Oxford. Winner of the 1966 *Irish Times* award for poetry and the 1973 Patrick Kavanagh award for her first collection, *Acts and Monuments*, published by Gallery Press in 1975, she is one of the most admired poets of her generation. She is currently Ireland Professor of Poetry.

Nuala Ní Dhomhnaill was born in 1952 in Lancashire but spent most of her childhood near Ventry in the west Kerry *Gaeltacht*. Educated at University College, Cork, she was involved there with the Irish language poetry magazine *INNTI*. She is one of the most popular and accessible poets writing in Irish today.

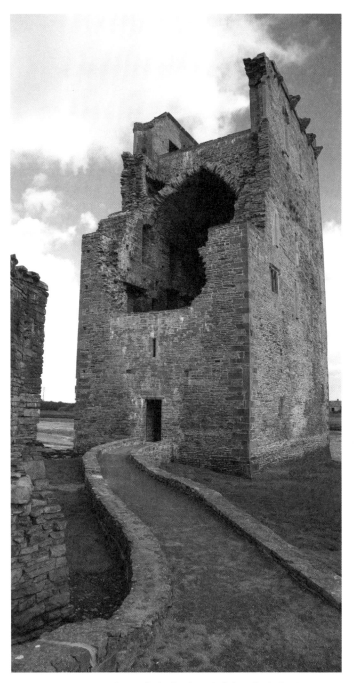

Carrigafoyle Castle in Ballylongford, Co. Kerry.

Áine Ní Ghlinn was born in 1955 in Gould's Cross, County Tipperary and educated at University College, Dublin. A teacher, journalist and broadcaster, she has written collections of poetry in Irish as well as non-fiction for younger readers.

Dáibhí Ó Bruadair (c.1625–1698) was born in East Cork where he had a good education in Irish, English, Latin and history. He was also trained in bardic poetry. From about 1660 he lived in County Limerick. After the Treaty of Limerick in 1691 and the subsequent Flight of the Wild Geese, among whom were his patrons the Fitzgeralds, he was reduced to working for a time as a farm labourer. He died in January 1698, sustained at the end by some of the older Irish families who still had property.

Eugene O'Connell was born near Kiskeam in North Cork in 1951. A primary school teacher by profession, he studied at Saint Patrick's Teacher Training College, Dublin and subsequently at University College, Cork under poets John Montague and Sean Lucy. Editor of *The Cork Literary Review*, he has published a number of books of poetry, the most recent being *Diviner*, Three Spires Press, Cork, 2009.

Bernard O'Donoghue was born in 1954 in Knockduff, Cullen, County Cork. Educated at Lincoln College, Oxford, he became a Fellow of Wadham College in 1995. Author of several acclaimed collections of poetry, in 1995 his collection *Gunpowder* won the Whitbread Award for Poetry.

John O'Donohue was born in 1956 in the Burren in County Clare. A priest of the Roman Catholic Church, he was awarded a PhD from the University of Tubingen in 1990. His first poetry collection was published by Salmon Poetry in 1994. His

acclaimed *Anam Cara: Spiritual Wisdom from the Celtic World* was published by Bantam Press in 1997. He died in 2008.

Denis O'Driscoll (1954–2012) was born in Thurles, County Tipperary and educated at University College, Dublin where he studied Law. He worked as a civil servant in Dublin. One of the foremost poets and critics of his generation, he published his *Stepping Stones: Interviews with Seamus Heaney* in 2008.

Desmond O'Grady (1935–2014), poet and translator, was born in Limerick and educated at University College, Dublin and at Harvard. In the 1950s he lived in Paris for a time. He moved to Italy in 1961 and became a friend of Ezra Pound's. Seamus Heaney has described him as 'one of the senior figures in Irish literary life, exemplary in the way he has committed himself over the decades to the vocation of poetry'.

Liam Ó Muirthile was born in Cork in 1950. One of the original *INNTI* group of poets, he studied French and Irish at University College, Cork. He worked with Gael-Linn before being appointed to the newsroom in RTÉ where he remained from 1973 until he left to become a full-time writer in 1993. He wrote a weekly column in Irish for the *Irish Times* from 1989 to 2003 and has published plays, novels, books of children's verse, articles, a collection of short fiction and five collections of poetry.

Seán Ó Ríordáin (1917–1977) was born in Ballyvourney, County Cork, at that time a *Gaeltacht* (Irish speaking) area but moved to Iniscarra near Cork city in 1932. One of the most influential Irish language poets of the twentieth century, he broke new ground with the publication of *Eireaball Spideoige*, his first collection, in 1952.

Leanne O'Sullivan was born in 1983 in Cork. She has won first prize in the Seacat Poetry Competition, the RTÉ Rattlebag Poetry Slam and the Davoren Hanna Award for Young Emerging Irish Poet. Her poetry collections are published by Bloodaxe.

Seán Ó Tuama was born in Blackpool, Cork city in 1926. He was educated at University College, Cork where he was taught English by Daniel Corkery, a major influence. He was appointed Associate Professor of Irish at University College, Cork in 1968 and was made Professor of Modern Irish Literature there in 1985. In 1997 his *Rogha Dánta/Selected Poems* was published by Cork University Press. He died in 2006.

Gabriel Rosenstock was born in 1949 in Kilfinane, County Limerick. He was educated at University College, Cork where he was one of the *INNTI* group of poets. He is a prolific poet and translator rendering, among others, Yeats, Heaney and George Trakl as well as numerous poems from the Arab tradition into Irish. He is a former Chairman of Poetry Ireland/ Éigse Éireann.

Eileen Sheehan was born and grew up in Scartaglin, County Kerry and now lives in Killarney. Winner of the inaugural Writers' Week, Listowel Poetry Slam (2004) and the Brendan Kennelly Poetry Award (2006) she has published two collections with Doghouse, Tralee. A third is forthcoming from Salmon Poetry.

Peter Sirr was born in Waterford in 1960 and was educated at Trinity College, Dublin. He lived in Holland and Italy for some time before returning to Dublin. He received the Patrick Kavanagh Award for Poetry in 1982. He is married to the poet Enda Wyley.

Jo Slade was born in 1952 in Berkhamsted, Hertsfordshire, England. A poet and painter, she was educated at Laurel Hill Convent, Limerick, Limerick College of Art and Design, the National College of Art, Dublin, Trinity College, Dublin and Mary Immaculate College, Limerick. Her poems have been translated into French, Spanish, Russian, Romanian and Slovenian. She lives and works in Limerick.

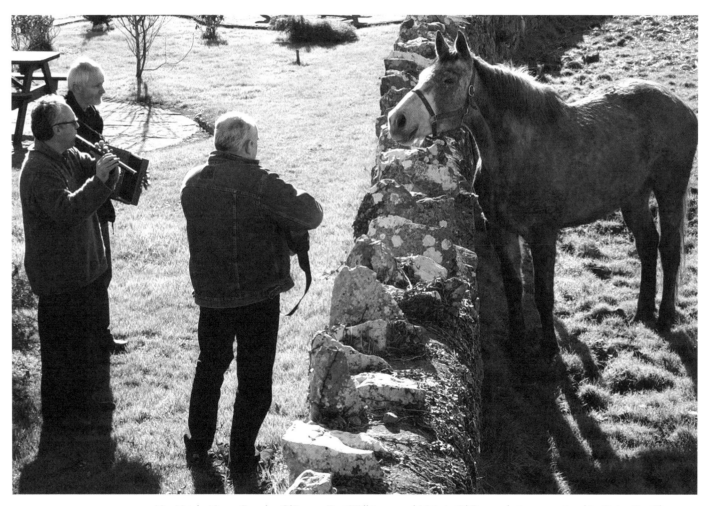

No, Neigh, Never: Brendan O'Regan, Desi Wilkinson and Máirtín O'Connor being appreciated in Quin, Co. Clare.

Paddy Bushe, poet and translator, was born in Dublin in 1948 and was educated at University College, Dublin. He lives in Waterville, County Kerry where he worked as a teacher until 1990. A prize-winning poet in Irish and English, he was the recipient of the *Oireachtas* Prize for Poetry in 2006 and in the same year was awarded the Michael Hartnett Poetry Prize.

Ciaran Carson, poet, translator and musician, was born in Belfast, where he lives with his family, in 1948. He spoke Irish until he was four years old. He was educated at Queen's University, Belfast. He worked as a teacher and civil servant before becoming Traditional Arts and Literature Officer with the Arts Council of Northern Ireland which he joined in 1975. Winner of the *Irish Times*/Aer Lingus Irish Literature Prize and the T S Eliot Prize, he is Professor of Poetry and Director of the Seamus Heaney Centre at Queen's University.

Gabriel Fitzmaurice (see above).

Brendan Kennelly (see above).

Paul Muldoon was born in 1955 near Moy in County Armagh and was educated at Queen's University, Belfast. He worked as a producer in Radio Ulster before moving to America in 1987. He is Howard G. B. Clark Professor in the Humanities at Princeton and a Distinguished Visiting Professor at Lancaster University. Winner of many awards, including the 2003 Pulitzer Prize for Poetry, he is regarded as one of the finest poets of his generation.

Frank O'Connor (pseudonym of Michael O'Donovan) (1903–1966), short story writer, translator and novelist, was born in Cork and reared in poverty by his mother largely in the absence of his father, a British soldier and Irish nationalist. His formal education ended at twelve years of age. During the Irish Civil War (1922–1923) he took the Republican side and was interned in Gormanstown in 1923. After his release he became a librarian and soon began to establish himself as a writer becoming probably the best short story writer Ireland has produced.

Bernard O'Donoghue (see above)

Pádraig Ó Snodaigh, poet, critic and publisher, was born in Carlow in 1935 and was educated locally and at University College, Dublin. He was Assistant Keeper of the National Museum from 1963–1988 and President of the Gaelic League from 1974–1979. He is the owner and publisher of *Coiscéim* which has been a major driving force in Irish-language publishing since the 1980s.

Seán Ó Tuama (see above).

Overleaf: Point to Point races on Littor Beach, Asdee on the Kerry side of the banks of the Shannon.

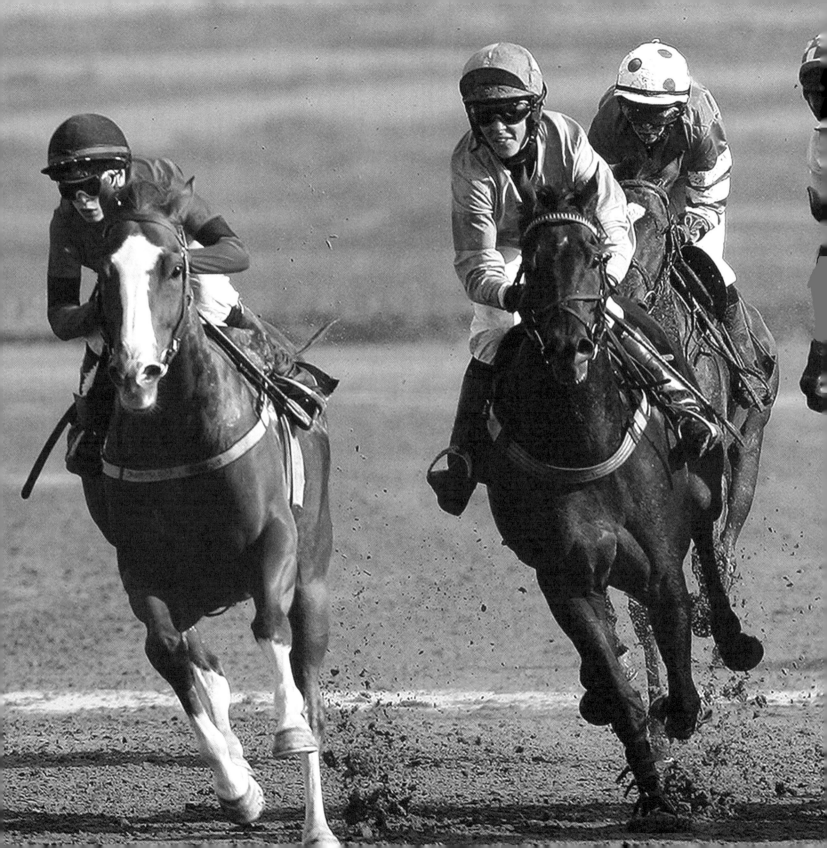

Brendan Kennelly

THE GIFT

It came slowly.
Afraid of insufficient self-content,
Or some inherent weakness in itself,
Small and hesitant,
Like children at the tops of stairs,
It came through shops, rooms, temples,
Streets, places that were badly-lit,
It was a gift that took me unawares,
And I accepted it.

Opposite: Wave-washed stones on Banna Strand.

Reeds and reflections.

Nuala Ní Dhomhnaill

THE LANGUAGE ISSUE

I place my hope on the water
in this little boat
of the language, the way a body might put
an infant

in a basket of intertwined
iris leaves,
its underside proofed
with bitumen and pitch,

then set the whole thing down amidst
the sedge
and bulrushes by the edge
of a river

only to have it borne hither and thither,
not knowing where it might end up;
in the lap, perhaps,
of some Pharaoh's daughter.

Translated from Irish by Paul Muldoon

Michael Hartnett

from A FAREWELL TO ENGLISH

for Brendan Kennelly

1

Her eyes were coins of porter and her West
Limerick voice talked velvet in the house:
her hair was black as the glossy fireplace
wearing with grace her Sunday-night-dance best.
She cut the froth from glasses with a knife
and hammered golden whiskies on the bar
and her mountainy body tripped the gentle
mechanism of verse: the minute interlock
of word and word began, the rhythm formed.
I sunk my hands into tradition
sifting the centuries for words. This quiet
excitement was not new: emotion challenged me
to make it sayable. The clichés came
at first, like matchsticks snapping from the world
of work: mánla, séimh, dubhfholtach, álainn, caoin:
they came like grey slabs of slate breaking from
an ancient quarry, mánla, séimh, dubhfholtach,
álainn, caoin, slowly vaulting down the dark
unused escarpments, mánla, séimh, dubhfholtach,
álainn, caoin, crashing on the cogs, splinters
like axeheads damaging the wheels, clogging
the intricate machine, mánla, séimh,
dubhfholtach, álainn, caoin. Then Pegasus
pulled up, the girth broke and I was flung back
on the gravel of Anglo-Saxon.
What was I doing with these foreign words?

I, the polisher of the complex clause,
wizard of grasses and warlock of birds
midnight-oiled in the metric laws?

5

I say farewell to English verse,
to those I found in English nets:
my Lorca holding out his arms
to love the beauty of his bullets,
Pasternak who outlived Stalin
and died because of lesser beasts:
to all the poets I have loved
from Wyatt to Robert Browning:
to Father Hopkins in his crowded grave
and to our bugbear Mr. Yeats
who forced us into exile
on islands of bad verse.

Among my living friends
there is no poet I do not love,
although some write
with bitterness in their hearts:
they are one art, our many arts.
Poets with progress
make no peace or pact:
the act of poetry
is a rebel act.

6

Gaelic is the conscience of our leaders,
the memory of a mother-rape they will
not face, the heap of bloody rags they see
and scream at in their boardrooms of mock oak.
They push us towards the world of total work,
our politicians with their seedy minds
and dubious labels, Communist or
Capitalist, none wanting freedom –
only power. All that reminds us
we are human and therefore not a herd
must be concealed or killed or slowly left
to die, or microfilmed to waste no space.
For Gaelic is our final sign that
we are human, therefore not a herd …

7

This road is not new.
I am not a maker of new things.
I cannot hew
out of the vacuumcleaner minds
the sense of serving dead kings.

I am nothing new.
I am not a lonely mouth
trying to chew
a niche for culture
in the clergy-cluttered south.

But I will not see
great men go down
who walked in rags
from town to town
finding English a necessary sin
the perfect language to sell pigs in.

I have made my choice
And leave with little weeping:
I have come with meagre voice
to court the language of my people.

dubhfholtach: blacklocked
álainn: beautiful
mánla, *séimh* and *caoin:* words whose meanings hover
 about the English adjectives graceful, gentle.

Dark reflections on Banna Strand as Ballyheigue lights twinkle.

Going nuts for winter food.

Rosita Boland

MR LARKIN

You seem to have said it all, you bastard,
Although writers have coined new words and expressions
That have entered easily into the English language,
Many of your poems have sunk in whole
So that to think of ambulances or high windows
Is to feel whole poems shiver and reverberate;
To feel that this is life faced up to dispassionately
And to have chuckled at it quietly
Without flinching at the bleakness of its reality.

You have pinned down something real and living
Within the frame and structure of your poems,
And they are not butterflies with gorgeous wings
They are dark-coloured moths
With strange antennae that reach out and out
Which I sometimes run from
But always return to,
Lifting the underside of those paper wings
And turning the pages of your calm, grim verse.

I feel I could add nothing but superfluities,
Yet that's what you'd have hated most –
To be set up as some type of guru
So I blunder on,
Often sobered by what you say
Yet immensely exhilarated by the manner
Of your saying it
And so – I blunder on.

Clean bones on the Cork–Kerry Mountains.

Brendan Kennelly

THE TIPPLER

Out of the clean bones
He tipples a hard music;
Cocking his head,
He knows himself sole master of his trade.
Hence his pride.

A goat ran wild
Through field and hillside,
Was tracked, caught, tethered, tamed,
Butchered and no man cried.
And the Tippler got his bones.

All bones dry in the sun,
Harden to browny white,
Mere flesh stripped and gone;
But bones create a new delight
When clacked by the proper man.

Let flesh lie rotten
When the Tippler takes his stand,
Holds the bones between his fingers;
Death has given him command,
Permitted him his hunger,

Made his heart articulate,
Tender, proud,
Clacking at shoulder, chest and head;
That man is for a while unbowed
Who brings music from the dead.

A lone figure in Lyreacrompane.

Michael Coady

SOLO

The last movement
must be avant garde,
unscored and unaccompanied
by lover, friend or mother.

Since finally
you'll have to make it
solo
and by ear

now's the time –
with the dance still on
and the band swinging –

now's the time
to stand up
and blow
ad lib

with all
the wrong notes
you dare.

Fiddlers Three: A break in a session at Browne's Bar, Castleisland.

Michael Coady

THOUGH THERE ARE TORTURERS

Though there are torturers in the world
There are also musicians.

Though, at this moment, men
Are screaming in prisons
There are jazzmen raising storms
Of sensuous celebration
And orchestras releasing
Glories of the spirit.

Though the image of God
Is everywhere defiled
A man in West Clare
Is playing the concertina,
The Sistine Choir is levitating
Under the dome of St. Peter's
And a drunk man on the road
Is singing for no reason.

Gateway to Slievenamon from the Fethard side.

Charles J. Kickham

SLIEVENAMON

Alone, all alone, by the wave-wash'd strand
And alone in the crowded hall.
The hall it is gay and the waves they are grand
But my heart is not here at all!
It flies far away, by night and by day,
To the times and the joys that are gone!
And I never can forget the sweet maiden I met
In the Valley near Slievenamon.

It was not the grace of her queenly air
Nor her cheek of the rose's glow,
Nor her soft black eyes, nor her flowing hair,
Nor was it her lily-white brow.
'Twas the soul of truth and of melting ruth,
And the smile like a Summer dawn,
That stole my heart away one soft Summer's day
In the Valley near Slievenamon.

In the festive hall, near the star-watch'd shore
Ever my restless spirit cries:
'My love, oh, my love, shall I ne'er see you more?
And, my land, will you never uprise?'
By night and by day, I ever, ever pray,
While lonely my life flows on,
To see our flag unrolled and my true love to enfold
In the Valley near Slievenamon.

William Pembroke Mulchinock

THE ROSE OF TRALEE

The pale moon was rising above the green mountain,
The sun was declining beneath the blue sea
When I strayed with my love to the pure crystal fountain
That stands in the beautiful vale of Tralee.
She was lovely and fair as the rose of the summer
Yet it was not her beauty alone that won me:
Oh no! 'Twas the truth in her eye ever dawning
That made me love Mary, the Rose of Tralee.

The cool shades of evening their mantle were spreading
And Mary all smiling was listening to me;
The moon through the valley her pale rays was shedding
When I won the heart of the Rose of Tralee.
Though lovely and fair as the rose of the summer,
Yet it was not her beauty alone that won me:
Oh no! 'Twas the truth in her eye ever dawning
That made me love Mary, the Rose of Tralee.

Opposite: Reaching for the sky in the Vandeleur Estate in Kilrush.

A ruin on the rich landscape in Cashel of Munster.

Anon

THE BOG-DEAL BOARD

I'd wed you, join without cow or coin or dowry too,
My own! My life! with your parents' consent if it so pleased you;
I'm sick at heart that we are not, you who make my heart to soar,
In Cashel of Munster with nothing under us but a bog-deal board.

Walk, my love, and come with me away to the glen,
And you'll find shelter, fresh air by the river and a flock bed;
Beneath the trees, beside us the streams will rush,
The blackbird we'll have for company and the brown song-thrush.

The love of my heart I gave you – in secret too;
Should it happen in the course of life that I and you
Have the holy bond between us and the ring that's true,
Then if I saw you, love, with another, I'd die of grief for you.

Translated from Irish by Gabriel Fitzmaurice

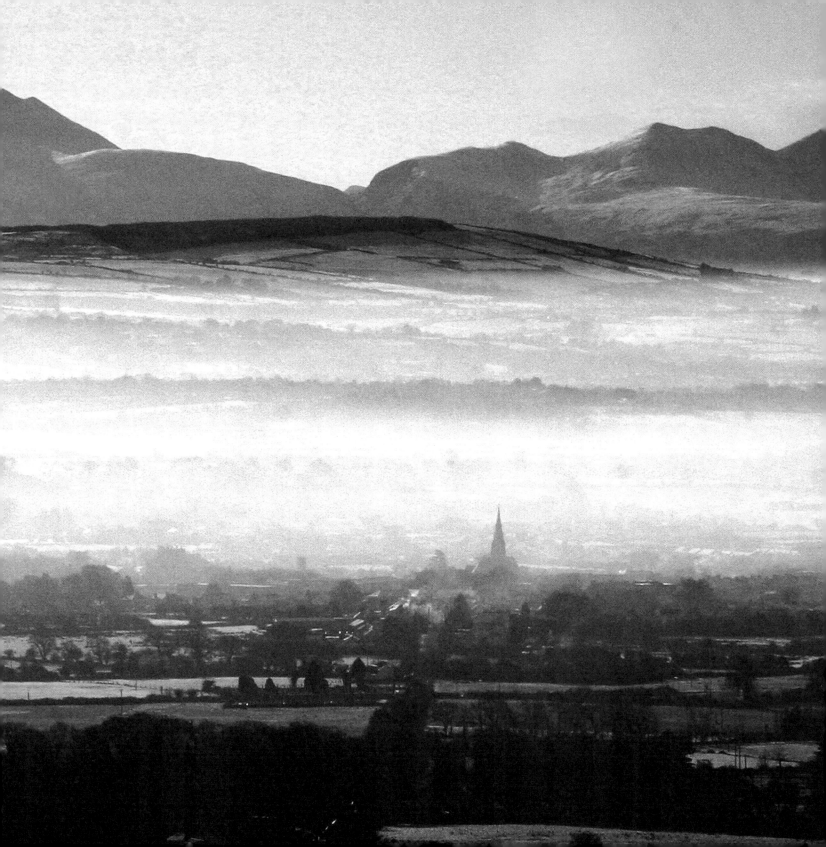

Eiléan Ní Chuilleanáin

TO NIALL WOODS AND XENYA OSTROVSKAIA
MARRIED IN DUBLIN ON 9 SEPTEMBER 2009

When you look out across the fields
And you both see the same star
Pitching its tent on the point of the steeple –
That is the time to set out on your journey,
With half a loaf and your mother's blessing.

Leave behind the places that you knew:
All that you leave behind you will find once more,
You will find it in the stories;
The sleeping beauty in her high tower
With her talking cat asleep
Solid beside her feet – you will see her again.
When the cat wakes up he will speak in Irish and Russian

And every night he will tell you a different tale
And the firebird that stole the golden apples,
Gone every morning out of the emperor's garden,
And about the King of Ireland's Son and the Enchanter's Daughter.

The story the cat does not know is the Book of Ruth
And I have no time to tell you how she fared
When she went out at night and she was afraid,
In the beginning of the barley harvest,
Or how she trusted to strangers and stood by her word:

You will have to trust me, she lived happily ever after.

Opposite: Castleisland from Glounsharoon.

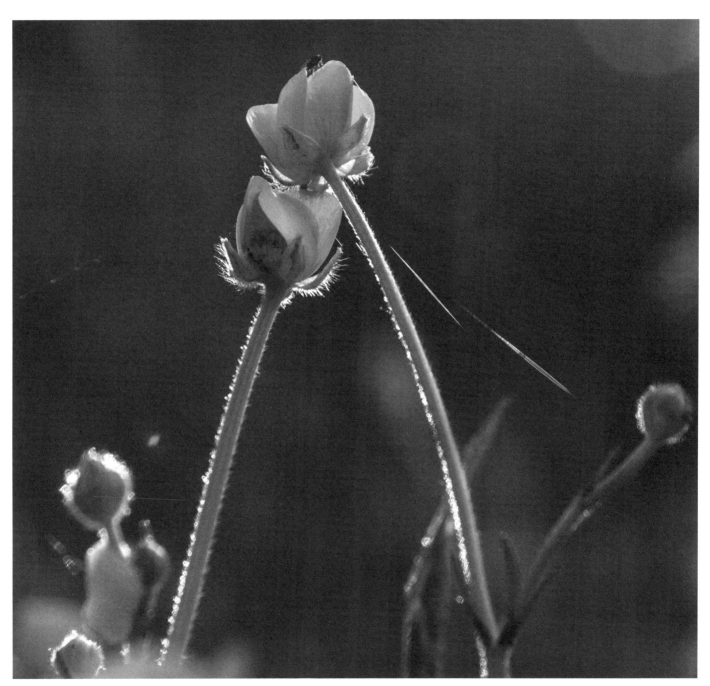

A pair of buttercups in a mid-summer dance in Knocknagore.

Gabriel Fitzmaurice

JUST TO BE BESIDE YOU IS ENOUGH

Just to be beside you is enough,
Just to make your breakfast tea and toast,
To help you with the ware, that kind of stuff,
Just to get the papers and your post;
To hold you in my arms in calm embrace,
Just to sit beside you at the fire,
Just to trace my fingers on your face
Is more to me than all of youth's desire;
Just to lie beside you in the night,
To hear you breathe in peace before I sleep,
To wake beside you in the morning light
In the love we sowed together that we reap.
Together we have taken smooth and rough.
Just to be beside you is enough.

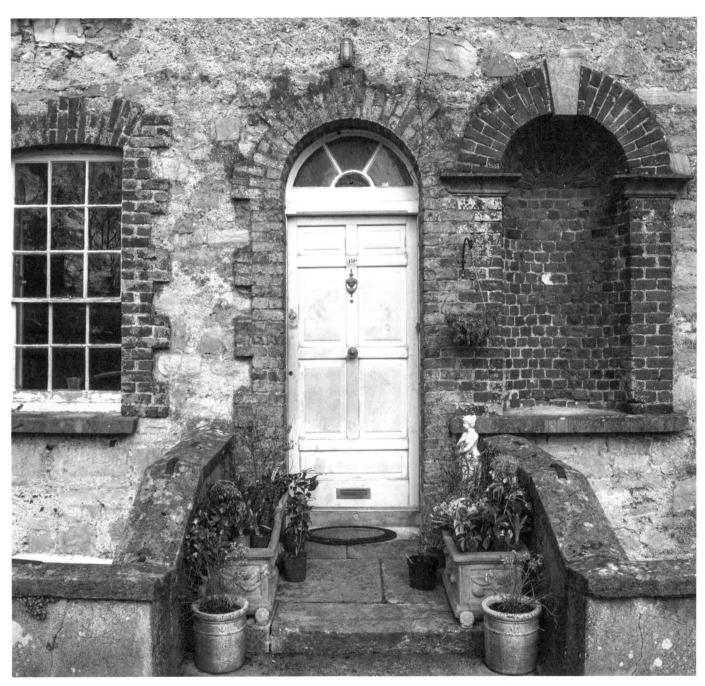

If doors could talk. King Square, Mitchelstown, Co. Cork.

Seán Ó Ríordáin

BROWN EYES

These brown eyes I see are hers
Now in her son's head,
It was a thing most beautiful
That you inherited;

It was a meeting privileged
With her mind and body too,
For a thousand years would pass so swift
If they but looked at you.

Because those eyes belong to her
It's strange that he has them,
I'm ashamed to face her now because
She happened in a man.

When she and they were one to me
Little did I think
Those eyes would change to masculine
That spoke so womanly.

Where is the source of madness
That's any worse than this?
Do I have to change my dialogue
Now that they are his?

She wasn't the first to see with them
Any more than he
Nor will he be the last
Who will wear them.

Is this all there is of eternity
That something of us lives on
Becoming masculine and feminine
From the mother to the son?

Translated from Irish by Gabriel Fitzmaurice

There's nothing wrong.

Eileen Sheehan

EGO

When she doesn't want to make love
he says, *What's wrong?*
as if something must be.

She says, *There's nothing wrong.*

He says, *But there must be something wrong,*
the master needing reasons.

She feels she should
have a note from her mother …

Dear Sir
would you please excuse my daughter from sex
the time of the month is not right
she's worried about the telephone bill
an earthquake rocked Tokyo tonight
she's afraid of waking the baby
Halley's Comet won't pass again for sixty seven years
she's afraid of making a baby
and the Dow Jones index showed
an unfavourable low at close of business
and you probably did it last night
two nights ago at the most …

He nudges her with his elbow,
Go on, you can tell me what's wrong.
Was it something I did? Something I said?

But there's nothing wrong I keep telling you.

Deflated, he heaves towards the wall,
taking his questions and most of the blankets.

Freezing on the edge of the world
she knows that nothing is wrong,
for tonight she has learned three things:

about ego,
the tug of the moon,
why women invented the headache.

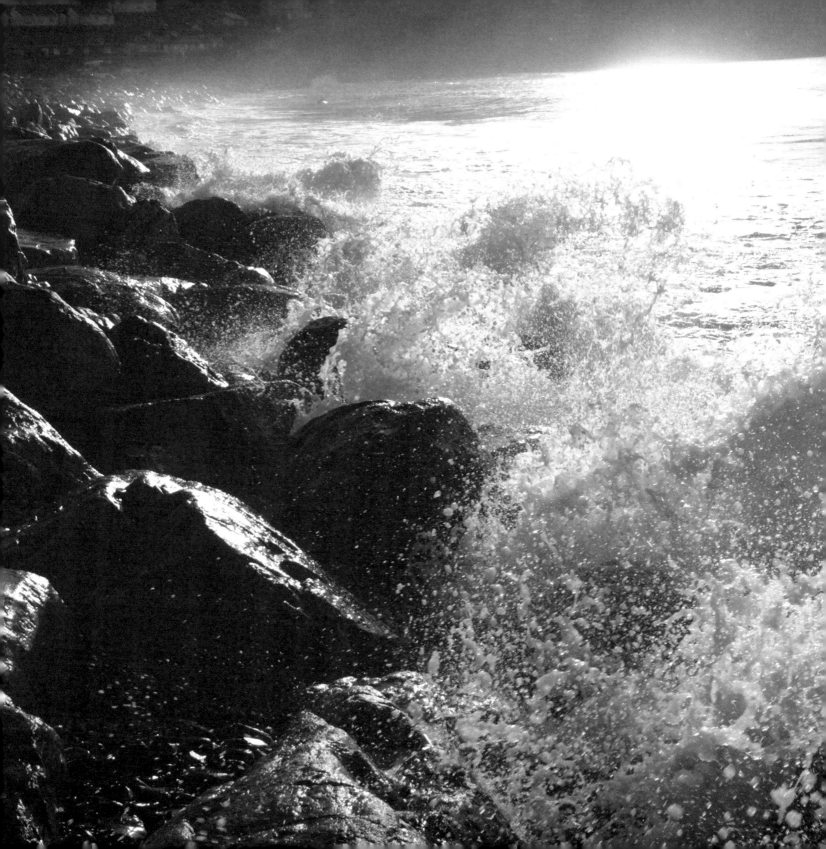

Thomas MacGreevy

HOMAGE TO MARCEL PROUST

to Jean Thomas

The sea gleamed a deep blue in the sunlight
Through the different greens of the trees.
And the talk was of singing.
My mother, dressed in black, recalled a bright image
from a song,
Those endearing young charms,
Miss Holly, wearing heliotrope, had a sad line,
The waves are still singing to the shore.
Then, as we came out from the edge of the wood,
The island lay dreaming in the sun across the bridge,
Even the white coastguard station had gone quietly to sleep
– it was Sunday,
A chain on a ship at the pier
Rattled to silence,
Cries of children, playing, sounded faintly
And, musically, somewhere,
A young sailor of the island –
 He was tall
 And slim
 And curled, to the moustaches,
 And he wore ear-rings
 But often he was too ill to be at sea –

Was singing,
Maid of Athens, ere we part …
Looking suddenly like a goddess
Miss Holly said, half-smiling,
'Listen …'
And we stopped
In the sunlight
Listening …

The young sailor is dead now.
Miss Holly also is dead.
And Byron …
Home they've gone and

And the waves still are singing.

Opposite: And the waves are still singing. Rossbeigh.

THE BALLAD OF THE TINKER'S SON

I was in school, 'twas the first of May,
The day the tinker came
With his wild wide eyes like a frightened hare's,
And his head with its thatch on flame.

We liked the length of his bare brown legs,
The patches upon his clothes,
The grimy strength of his unwashed hands
And the freckles about his nose.

The master polished his rimless specs
And he stared at him hard and long,
Then he stood him up on a shaky bench
And called on him for a song.

The tinker boy looked at our laughing lips,
Then with a voice like a timid bird's
He followed the master's bidding
And these are his singing words.

'My father was jailed for sheep-stealing,
My mother is black as a witch,
My sister off-ran with the Sheridan clan,
And my brother's dead-drunk in a ditch.

'O, Tralee jail would kill the devil,
But Tralee jail won't kill my da,
I'll mend ye a kettle for one-and-fourpence
And bring home porter to my ma.'

He bowed his head as the schoolhouse shook
With the cheers of everyone,
Then the master made me share my desk
With the raggedy tinker's son.

The days dragged by and he sat down there,
His brown eyes still afraid,
He heard the scholars' drowsy hum
And, turning to me, he said …

'Now what would I want with X and Y
And I singing the crooked towns,
Or showing a drunken farmer
The making of silver crowns?

'And will Euclid teach me to light a fire
Of green twigs in the rain,
Or how to twist a pheasant's neck
So it will not shout with pain?

'And what would I want with ancient verse
Or the meaning of Latin words
When all the poetry I'll ever need
Rings the throats of the singing birds?'

But he stayed at school and his flowering mind
Grew quick as a swooping hawk;
Then came a day when we said goodbye
To the master who smelt of chalk.

He went to the life of the ribbon roads
And the lore of the tinker bands;
They chained my bones to an office stool
And my soul to a clock's cold hands.

But I often thought of my tinker friend
And I cursed the smirking luck
That didn't make me a tinker man
Fighting the road to Puck

With a red-haired wife and a piebald horse,
And a splendid caravan,
Roving the roads with Cartys and Wards,
The O'Briens or the Coffey clan.

The years went by and the Trouble came,
And I found myself again
Back where I whittled the worn desks,
With the mountains and the rain.

They put a trench-coat on my back,
And in my hands a gun,
And up in the hills with the fighting men
I found the tinker's son.

And there on the slopes of the Kerry hills
Our love grew still more strong,
And we watched the wrens on the yellow whins
Spill their thimblefuls of song.

There came a truce and I shook his hand,
For a while our fighting done;
But I never spoke a word again
To the red-haired tinker's son …

'Tis many a year since he went away
And over the roads the vans
Wheel gaily to horse and cattle fairs
With the O'Brien and the Coffey clans.

The tinker's son should be back again
With the roads and the life he knew,
But I put a bullet through his brain
In nineteen twenty-two.

The Trouble: the Anglo–Irish War of 1919–21
Nineteen twenty-two: the Irish Civil War.

Ballyheigue Bay.

Bryan MacMahon

WHAT THE TINKER WOMAN SAID TO ME

Ah, may Jesus relieve you in your hardesht hoult,
My lovely man. Like myself you are
Black hair, brown eyes, yalla shkin –
That's your beauty and my beauty;
It's the trade-mark of the Wards.
Buried above here I'll be, right appusit the yew tree,
First turn to the left, first turn to the right,
Twenty, maybe thirty paces, halt, Black Bridgie Ward!
I love you, sir.
I love you for your hair, your eyes, your shkin.
It's in four of me grandsons.
I got four after meself and four after their foxy father –
(I can't shtick foxy people!)
As sure as Christ was nelt, sir, I suffered my share.
But I have my health.
Indeed I have, sir.
Over in Ballyheigue I am: I'll tell you no word of a lie.
A mother, sir.
That I may be sainted to the Almighty God,
I shtarts thinkin' of my son Timothy – Thigeen we calls him
That's in the sannytorium above here, sir,
An' the minute I starts thinkin' of him
A batterin' ram, sir,
Couldn't come bethune me an' my lovely boy.
I sat into my daughter's car, sir, and covered the
Fourteen Irish mile o' ground.
I went in above.
'Hello, Ma!', says he laughin'.
He's my son, sir, my lawful-got son!

The heart ruz up in me but I held it back.
'Oh yeah', says I, 'isn't it full o' funnin' you are?'
'Where are ye now, Ma?', says he.
'In Ballyheigue', says I.
I had my daughter's daughter with me – a bit of a
childeen barely beginnin' to walk.
'Cuckoo!', says he, gamin' for the benefit of the child.
The child was class of shy: We commenced laughin'.
'You're a godfather, Thady', says I.
'Unknownsht to yourself.
Bridgie, your sister, had two more since you left'.
(That's his sister's children, sir!)
With that he fell to laughin' on account of he bein' a
 godfather unknownsht to him.
I left him there, sir.
Shtandin' at the winda advanced in his disease
And we takin' to the road.
I re'ched up my hand in his direction, sir, and I sittin'
Into my daughter's green car.
He stood there till we rounded the gateposht.
I'll tell you no word of a lie. That's a mother!
Easter Saturday that was.
At Chrussmass we were up in Newtown.
'Christmas is it', I said, 'an' no Timothy'.
It came to Saint Patrick's Day.
In the middle o' my carousin' I shtopped an' said:
'Patrick's Day an' no Thigeen.
Listowel Races an' no Timothy.
Puck Fair an' no Timothy'.

Shtandin' at the winda he was,
Black hair,
Brown eyes,
Yalla shkin.
Buried above here, appusit the yew tree he'll be
First turn to the left
First to the right
Twenty, maybe thirty paces
Halt, BLACK THADY WARD!

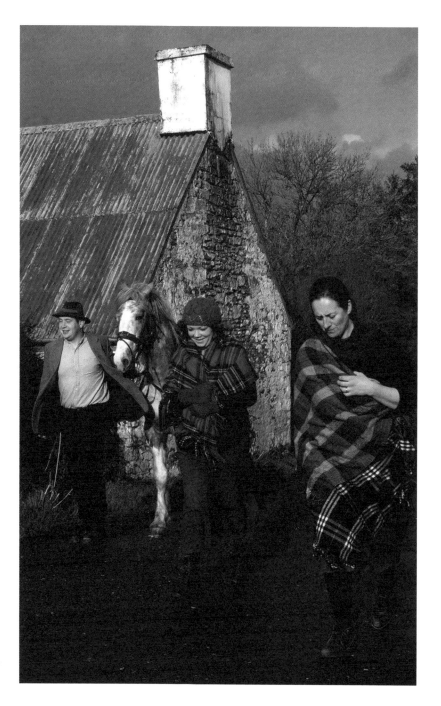

Sliabh Luachra drama group members:
Danny O'Leary, Moira Hughes and Nora Walsh in a
scene from the J. M. Synge play, *The Tinker's Wedding*.

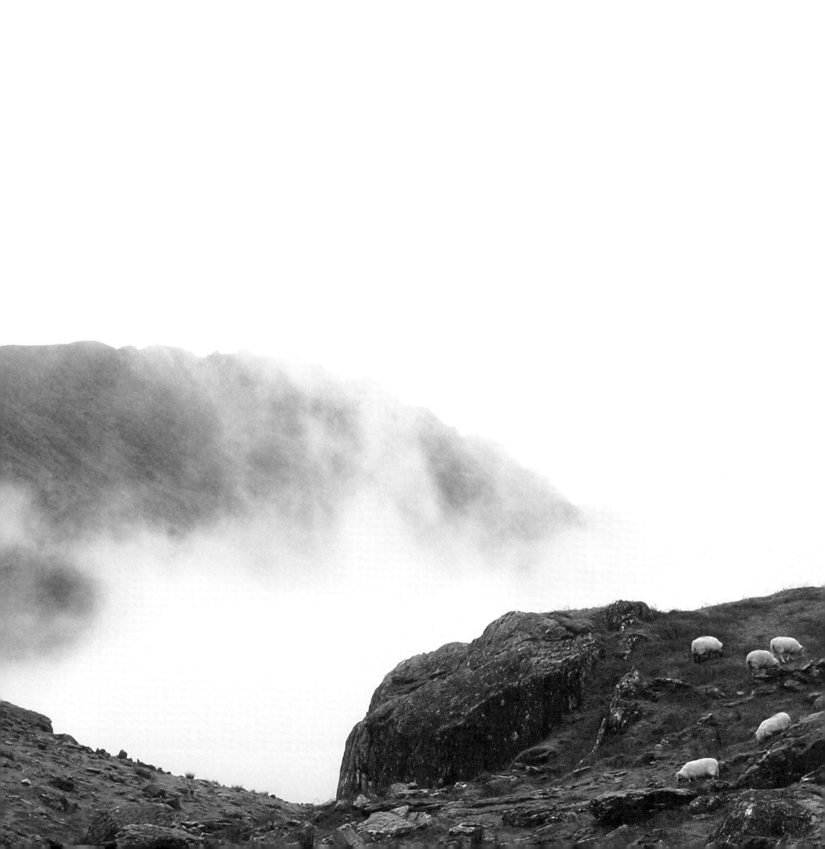

THE BETRAYAL

a poem for my father

This man is seriously ill
the doctor had said a week before,
calling for a wheelchair.
It was
after they rang me
to come down
and persuade you
to go in
condemned to remember your eyes
as they met mine in that moment
before they wheeled you away.
It was one of my final tasks
to persuade you to go in,
a Judas chosen not by Apostles
but by others more broken;
and I was, in part,
relieved when they wheeled you from me,
down that corridor, confused,
without a backward glance.
And when I had done it,
I cried, out in the road,
hitching a lift to Galway, and away
from the trouble of your
cantankerous old age
and rage too,
at all that had in recent years
befallen you.

All week I waited to visit you
but when I called, you had been moved
to where those dying too slowly
were sent,
a poorhouse, no longer known by that name,
but, in the liberated era of Lemass,
given a saint's name, 'St Joseph's'.
Was he Christ's father,
patron saint of the Worker,
the mad choice of some pietistic politician?
You never cared.

Nor did you speak too much.
You had broken an attendant's glasses,
the holy nurse told me,
when you were admitted.
Your father is a very difficult man,
as you must know. And Social Welfare is slow
and if you would pay for the glasses,
I would appreciate it.
It was 1964, just after optical benefit
was rejected by de Valera for poorer classes
in his Republic, who could not afford,
as he did,
to travel to Zurich
for their regular tests and their
rimless glasses.

Opposite: Sheep may safely graze. The Cork–Kerry Mountains.

It was decades earlier
you had brought me to see him
pass through Newmarket-on-Fergus
as the brass and reed band struck up,
cheeks red and distended to the point
where a child wondered whether
they would burst as they blew
their trombones.
The Sacred Heart Procession and de Valera,
you told me, were the only occasions
when their instruments were taken
from the rusting, galvanised shed
where they stored them in anticipation
of the requirements of Church and State.

Long before that, you had slept
in ditches and dug-outs,
prayed in terror at ambushes
with others who later debated
whether de Valera was lucky or brilliant
in getting the British to remember
that he was an American.
And that debate had not lasted long
in concentration camps in Newbridge
and the Curragh, where mattresses were burned,
as gombeens decided that the new State
was a good thing,
even for business.

In the dining room of St Joseph's
the potatoes were left in the middle of the table,
in a dish, towards which
you and many other Republicans

stretched feeble hands that shook.
Your eyes were bent as you peeled
with a long thumbnail I had often watched
scrape a pattern on the leather you had toughened for our
shoes.
Your eyes when you looked at me
were a thousand miles away,
now totally broken,
unlike those times even
of rejection, when you went at sixty
for jobs you never got,
too frail to load vans, or manage
the demands of selling.
And I remember
when you came back to me,
your regular companion on such occasions,
and said: 'They think that I'm too old
for the job. I said that I was fifty-eight
but they knew that I was past sixty.'

A body ready for transportation,
fit only for a coffin, that made you
too awkward
for death at home.
The shame of a coffin exit
through a window sent you here,
where my mother told me you asked
only for her to place her cool hand
under your neck.
And I was there when they asked
would they give you a Republican funeral,
in that month when you died,
between the end of the First Programme for Economic

Expansion
and the Second.

I look at your photo now,
taken in the beginning of bad days,
with your surviving mates
in Limerick.
Your face haunts me, as do these memories;
and all these things have been scraped
in my heart,
and I can never hope to forget
what was, after all,
a betrayal.

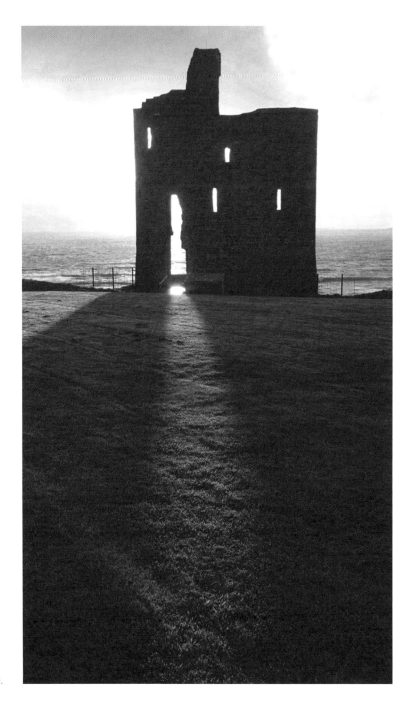

Long shadows for long years: Ballybunion Castle.

Tim Cunningham

INTROIT

'Introibo ad altare Dei,
Ad Deum Qui laetificat juventutem meam.'

'I will go unto the altar of God,
To God who gives joy to my youth.'

The stone steps to the church are smoother now,
The stone steps slippery with Limerick rain.

This was our theatre and concert hall,
Art gallery and, some would say, museum.

First steps to the thrill of pageantry,
Gazing at the monstrance, cope, the cloth-of-gold,

Dazzled by the multi-coloured light
Of stained-glass windows, their jig-saw saints.

The pieta was not Carrara marble
But still echoed that Michelangelo.

The extracts from epistle and gospel
Knitted to our 'Golden Treasury',

And 'Hamlet' and 'King Lear' had competition
From the drama of crib and crucifix,

Our priest actors no less theatrical
In seasonal vestments. Again, all male.

A shy soprano in the gallery
Could dream 'La Traviata' at the Met.

All this and the comfort of belief.
Youth gifted with the joy of possibility

Beckoning to feet on two stone steps
Slippery with rain and holy water.

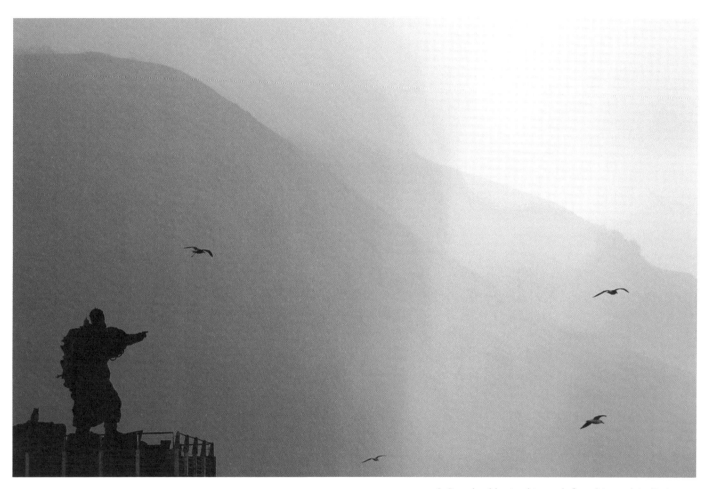

St Brendan blessing his patch from his perch in Fenit.

John O'Donohue

BEANNACHT

for Josie, my mother

On the day when
the weight deadens
on your shoulders
and you stumble,
may the clay dance
to balance you.

And when your eyes
freeze behind
the grey window
and the ghost of loss
gets in to you,
may a flock of colours,
indigo, red, green
and azure blue
come to awaken in you
a meadow of delight.

When the canvas frays
in the currach of thought
and a stain of ocean
blackens beneath you,
may there come across the waters
a path of yellow moonlight
to bring you safely home.

May the nourishment of the earth be yours,
may the clarity of light be yours,
may the fluency of the ocean be yours,
may the protection of the ancestors be yours.

And so may a slow
wind work these words
of love around you,
an invisible cloak
to mind your life.

currach: a coracle

Dennis O'Driscoll

MISSING GOD

His grace is no longer called for
before meals: farmed fish multiply
without His intercession.
Bread production rises through
disease-resistant grains devised
scientifically to mitigate His faults.

Yet, though we rebelled against Him
like adolescents, uplifted to see
an oppressive father banished –
a bearded hermit – to the desert,
we confess to missing Him at times.

Miss Him during the civil wedding
when, at the blossomy altar
of the registrar's desk, we wait in vain
to be fed a line containing words
like 'everlasting' and 'divine'.

Miss Him when the TV scientist
explains the cosmos through equations,
leaving our planet to revolve on its axis
aimlessly, a wheel skidding in snow.

Miss Him when the radio catches a snatch
of plainchant from some echoey priory;
when the gospel choir raises its collective voice
to ask *Shall We Gather at the River?*
or the forces of the oratorio converge

on *I Know That My Redeemer Liveth*
and our contracted hearts lose a beat.

Miss Him when a choked voice at
the crematorium recites the poem
about fearing no more the heat of the sun.

Miss Him when we stand in judgement
on a lank Crucifixion in an art museum
its stripe-like ribs testifying to rank.

Miss Him when the gamma-rays
recorded on the satellite graph
seem arranged into a celestial score,
the music of the spheres,
the *Ave Verum Corpus* of the observatory lab.

Miss Him when we stumble on the breast lump
for the first time and an involuntary prayer
escapes our lips; when a shadow crosses
our bodies on an x-ray screen; when we receive
a transfusion of foaming blood
sacrificed anonymously to save life.

Miss Him when we call out His name
spontaneously in awe or anger
as a woman in the birth ward bawls
her long-dead mother's name.

Miss Him when the linen-covered
dining table holds warm bread rolls,
shiny glasses of red wine.

Miss Him when a dove swoops
from the orange grove in a tourist village
just as the monastery bell begins to take its toll.

Miss Him when our journey leads us
under leaves of Gothic tracery, an arch
of overlapping branches that meet
like hands in Michelangelo's creation.

Miss Him when, trudging past a church,
we catch a residual blast of incense,
a perfume on par with the fresh-baked loaf
which Milosz compared to happiness.

Miss Him when our newly-decorated kitchen
comes in Shaker-style and we order
a matching set of Mother Ann Lee chairs.

Miss Him when we listen to the prophecy
of astronomers that the visible galaxies
will recede as the universe expands.

Miss Him the way an uncoupled glider
riding the evening thermals misses its tug.

Miss Him, as the lovers shrugging
shoulders outside the cheap hotel
ponder what their next move should be.

Even feel nostalgic, odd days,
for His Second Coming,
like standing in the brick
dome of a dovecote
after the birds have flown.

Free of its load. A God-and-man-forsaken tractor in
a field in Lyreacrompane.

The Millennium Fountain in Lismore, Co. Waterford.

Pádraig J. Daly

GOD IN WINTER

1

We have exhausted ourselves doing good,
Building our infected kingdom,
And have wept to see the tempests take it.

Now we lay our burden down
And wait for You,
Who have been tending elsewhere,

To stun us in the wilderness
With sudden shoots.

2

As when the sun on a bleak day
Makes its somehow way
Through an overhang of trees
Onto a river
And the swift race dances onward
Splotched with gold,

So, in grey weathers,
Your mirthful manifesting.

3

In the hush when the bread has been shared
And the shuffle back to the pews has stopped
And the choir is silent for a time:
The rustle of divinity.

The magnificent Lismore Castle in Co. Waterford.

An unusual, cast-iron, wall-mounted signpost in Lismore.

Seán Dunne

AGAINST THE STORM

War gathers again and the stern
generals argue over outspread maps.
Bullets shatter the high
pulpit where a prelate pleads.
Ministers rant on platform
until words discard meaning and collapse.
Everywhere unease spreads like rumour.

Before it was the same, and small
signals went unnoticed in the dark.
The gross cloud changed nothing despite
the thronged chambers, the skin
shed like a stocking in the bomb's wake.
Afterwards, the cafes opened and stark
lessons were unlearned. Unreal and loud,
laughter drowned the warnings calling

urgent as the cry of a trapped hare.
In spite of headlines now I catch
the stir of my sleeping son
turning to begin his second year.
Against all horror I set such acts,
intimate and warm as gathered friends
huddled in a room against the storm
or around the table for a final meal.

Opposite: Bare Tree – Laden Sky. Ballyline on the Listowel to Ballylongford Road, Co. Kerry.

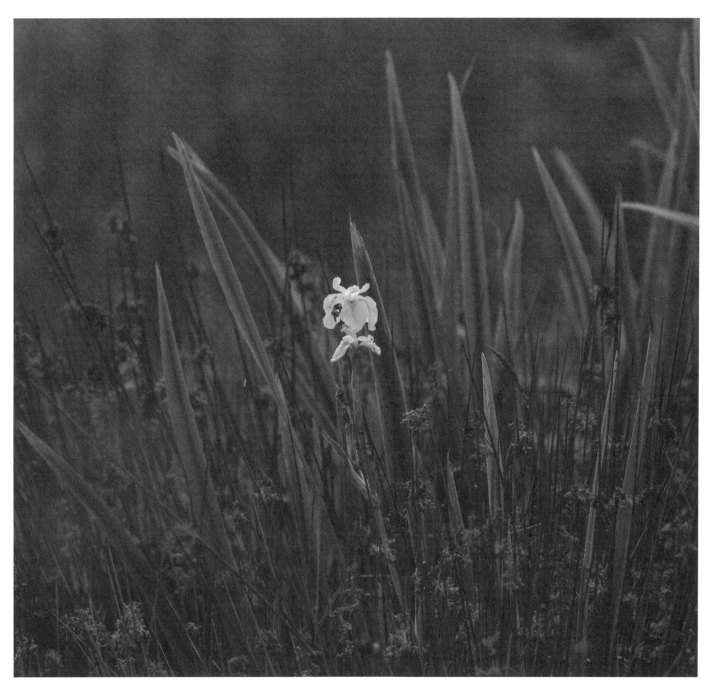

Showing its colours. A lone iris lending its beauty in a mixed meadow. Moanmore, Castleisland.

Thomas McCarthy

GOOD NIGHT

Will you leave the light, Tom? Just a while.
You've already discovered what night means
Now that the bars have come down from your cot;
Nothing to protect you but the brittle
Cobwebby veil of sleep. Four a.m. scenes
And repeated stories are all we've got
To send you back to the enveloping peace.
And where does it come from, this new disease
Of darkness, the fear of the night's unseen?
How many deaths have you witnessed on the small screen
Already, murders while nappy-changing,
Shooting between bottles and Sudocrem?
No Care Bears can protect your naked toes,
No Megan watch the sky while you doze.

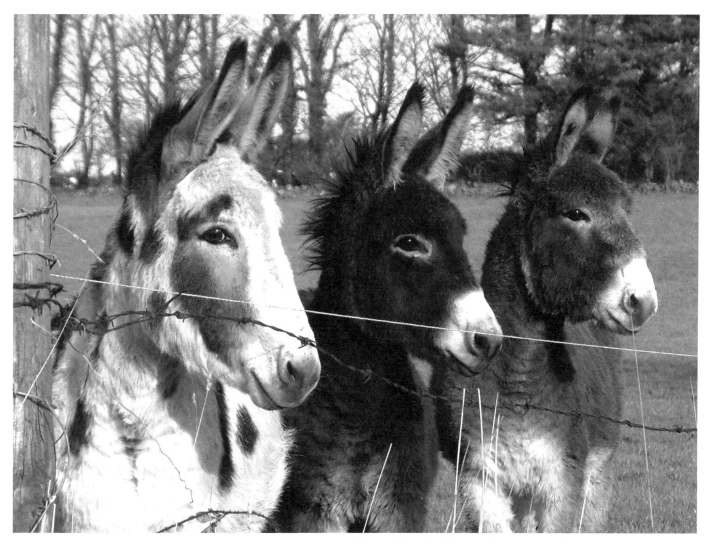

Three donkeys locked on to the happenings of the village in Scartaglin.

Gabriel Rosenstock

TELEVISION

for my daughter Saffron

At five o'clock in the morning
She wanted television.
Who can argue with a little woman
Two and a half years old?
Down we went together
I didn't even dress
And the room was freezing.
No light yet in the sky
We stared in wonder at the white screen.
Happy now?
But she saw snow
And a giraffe through it
And an arctic owl
Wheeling
Above it.

Translated from Irish by Gabriel Fitzmaurice

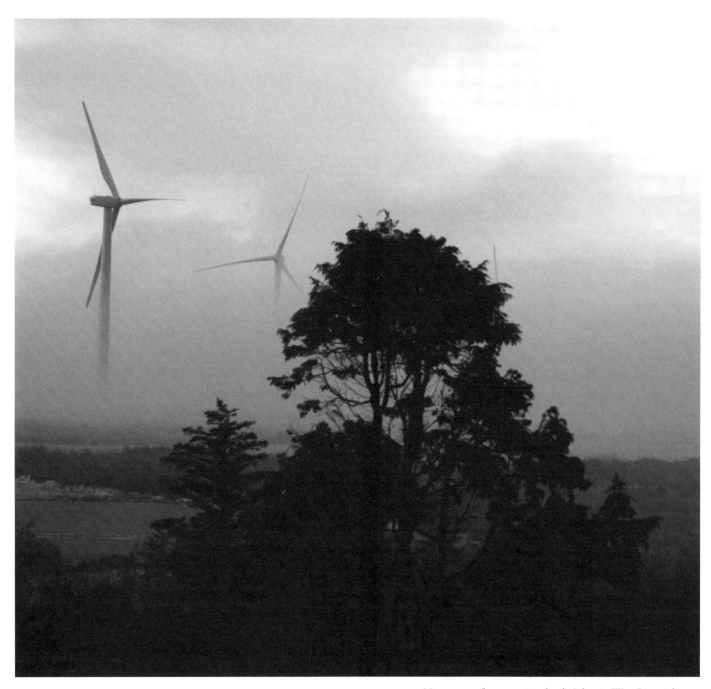

New energy for an ancient land. Athea in West Limerick.

Peter Sirr

SLIPPING INTO IT

The beautiful, impossible
busyness of it: the darting,
flitting quickness, the panicked
raids and returns, relentless,
rifling the grasses and back
to the gap under the gutter
above the bedroom window

where I place you now
on the deep sill to watch.
'Blue tits', I say, pointing.
'Blue tits', you agree, slipping
into it, as if you'd always
known, and this
furious hover above your head

had always been there
waiting to flower. Nothing,
and everything, surprises you
though this, for years,
will pass you by: the desperation
of the labour, how few survive,
how little of what we see

is known to us. But now
the wings beat outside the window,
the sunlit grasses loom
like ships in harbour, and wherever
you look the light arrives,
and the hatches open
on endless, urgent cargoes.

Parked up for prayer at St Mary's Parish
Church on a Sunday afternoon in Listowel.

Brian Merriman

from THE MIDNIGHT COURT

'But oye, my heart will grow grey hairs
Brooding forever on idle cares,
Has the Catholic Church a glimmer of sense
That the priests won't marry like anyone else?
Is it any wonder the way I am,
Out of my mind for want of a man,
When there's men by the score with looks and leisure,
Walking the roads and scorning pleasure?
The full of a fair of primest beef,
Warranted to afford relief,
Cherry-red cheeks and bull-like voices,
And bellies dripping with fat in slices,
Backs erect and heavy hind quarters,
Hot-blooded men, the best of partners,
Freshness and charm, youth and good looks
And nothing to ease their mind but books!
The best fed men that travel the country,
Beef and mutton, game and poultry,
Whiskey and wine forever in stock,
Sides of bacon, beds of flock.
Mostly they're hardy under the hood,
And we know like ourselves they're flesh and blood;
I wouldn't ask too much of the old campaigners,
The good-for-nothings and born complainers,
But petticoat-tossers aloof and idle
And fillies gone wild for bit and bridle!

Of course I admit that some more sprightly
Would like to repent and I'd treat them lightly.
A pardon and a job for life
To every cleric that takes a wife!
For many a good man's chance miscarries
If you scuttle the ship for the crooks it carries;
And though some as we know were always savage
Gnashing their teeth at the thought of marriage,
And, modest beyond the needs of merit,
Invoked hell-fire on girls of spirit,
Yet some that took to their pastoral labours
Made very good priests and the best of neighbours.
Many a girl filled byre and stall
And furnished her house through a clerical call.
Everyone's heard of priests extolled
For lonesome women that they consoled;
People I've heard throughout the county
Have nothing but praise for the curate's bounty;
Or uphold the canon to lasting fame
For the children he reared in another man's name;
But I hate to think of their lonely lives,
The passions they waste on middle-aged wives,
While the women they'd choose if the choice were theirs
Go by the wall and comb grey hairs.
It passes the wit of mortal man
What Ireland has lost by this stupid ban.

Translated from Irish by Frank O'Connor

Anon

THE OLD WOMAN OF BEARE

The sea crawls from the shore
Leaving there
The despicable weed,
A corpse's hair.
In me,
The desolate withdrawing sea.

The Old Woman of Beare am I
Who once was beautiful.
Now all I know is how to die.
I'll do it well.

Look at my skin
Stretched tight on the bone.
Where kings have pressed their lips,
The pain, the pain.

I don't hate the men
Who swore the truth was in their lies.
One thing alone I hate –
Women's eyes.

The young sun
Gives its youth to everyone,
Touching everything with gold.
In me, the cold.

The cold. Yet still a seed
Burns there.

Women love only money now
But when
I loved, I loved
Young men.

Young men whose horses galloped
On many an open plain
Beating lightning from the ground,
I loved such men.

And still the sea
Rears and plunges into me,
Shoving, rolling through my head
Images of the drifting dead.

A soldier cries
Pitifully about his plight;
A king fades
Into the shivering night.

Does not every season prove
That the acorn hits the ground?
Have I not known enough of love
To know it's lost as soon as found?

I drank my fill of wine with kings,
Their eyes fixed on my hair;
Now among the shrinking hags
I chew the cud of prayer.

Time was the sea
Brought kings as slaves to me,
Now I near the face of God
And the crab crawls through my blood.

I loved the wine
That thrilled me to my fingertips;
Now the mean wind
Stitches salt into my lips.

The coward sea
Slouches away from me.
Fear brings back the tide
That made me stretch at the side
Of him who'd take me briefly for his bride.

The sea grows smaller, smaller now.
Farther, farther it goes
Leaving me here where the foam dries
On the deserted land,
Dry as my shrunken thighs,
As the tongue that presses my lips,
As the veins that break through my hands.

Translated from Irish by Brendan Kennelly

DIO AND ELECTRICAL STORE

Patrick Galvin

THE MADWOMAN OF CORK

Today
Is the feast day of Saint Anne
Pray for me
I am the madwoman of Cork.

Yesterday
In Castle Street
I saw two goblins at my feet
I saw a horse without a head
Carrying the dead
To the graveyard
Near Turner's Cross.

I am the madwoman of Cork
No one talks to me.

When I walk in the rain
The children throw stones at me
Old men persecute me
And women close their doors.
When I die
Believe me
They'll set me on fire.

I am the madwoman of Cork
I have no sense.

Sometimes
With an eagle in my brain
I can see a train
Crashing at the station
If I told people that
They'd choke me.
Then where would I be?

I am the madwoman of Cork
The people hate me.

When Canon Murphy died
I wept on his grave
That was twenty-five years ago.
When I saw him just now
In Dunbar Street
He had clay in his teeth
He blest me.

I am the madwoman of Cork
The clergy pity me.

I see death
In the branches of a tree
Birth in the feathers of a bird.
To see a child with one eye
Or a woman buried in ice
Is the worst thing
And cannot be imagined.

I am the madwoman of Cork
My mind fills me.

I should like to be young
To dress up in silk
And have nine children.
I'd like to have red lips
But I'm eighty years old.
I have nothing
But a small house with no windows.

I am the madwoman of Cork
Go away from me.

And if I die now
Don't touch me.
I want to sail in a long boat
From here to Roche's Point
And there I will anoint
The sea
With oil of alabaster.

I am the madwoman of Cork
And today
Is the feast day of Saint Anne.
Feed me.

Window to an emptiness within. Outer wall, Carrigafoyle Castle.

Liam Ó Muirthile

FRIENDSHIP

Your beard was always thick, jetblack.
One morning in the Galway B and B
you showed me how to soften up the boyish growth
on my own face with water
before shaving it with the blade.
You are broken now on a bench in a human dump
like a pair of old trousers discarded in the corner.
It's your darkness that first comes back to mind
in the hospital, visiting you by bike one afternoon.
I am ashamed of my togetherness in your presence.
The patients are playing ping-pong with the fragments of your head;
one pane is missing from the beehive window
and a patient in his underpants sticks his hand through it
every couple of minutes. You say you miss Beethoven.
They won't let us out to walk in the garden –
afraid no doubt the flowers might catch schizophrenia
and scream at Wordsworth at the top of their voices –
and I am ashamed again when you say fervently
that you'd like me to get you a piano in the asylum
so you could spend your days fingering
the terrible silent notes of solitude.

Translated from Irish by Bernard O'Donoghue

Eibhlín Dhubh Ní Chonaill

from THE HOWL FOR ART Ó LAOGHAIRE

(i)
My love holds fast in you!
The day I chanced on you
Beside the market-house,
You were my eye's distraction,
You were my quickened heartbeat,
I left home and family
To travel far with you.

(ii)
It never went bad for me:
You had the parlour cleaned for me,
Rooms painted to please me,
Ovens well-heated for me,
Trout by the gills for me,
Spitted roast meat for me,
Slaughtered beasts for me;
Duck-down sleep for me
Until the cows came home –
Even more, if it pleased me.

(iii)
My firmest friend!
It lives in me always,
That boisterous spring day;
How well it became you,
That gold-banded beaver,
Your silver-hilted sabre
Held in highhanded bravery –

The swaggering, the daring
Had your enemies shaking,
Venomous, but craven;
You ready for a tearaway
On your white-faced mare.
The English abased themselves
Down towards the clay then,
And not for your own sake
But for how much you scared them,
Though you got your grave from them,
My heart's dearest favourite.

(iv)
My chevalier, white-handed!
How well your jeweled tie-pin
Pierced firmly through the cambric,
And the lacing adorned your hat.
When you came from abroad to us
They'd clear the road for you
And never out of love for you,
But with their deepest curse for you.

(v)
My lover, now and always!
When they come into the hallway
Conchubhar, everyone's favourite,
And Fear Ó Laoghaire, the small one,
They'll ask, all hot and bothered,
Where I have left their father.

I'll tell them through my horror
He's beyond in Cill na Martar.
They'll call out for their father,
With silence for an answer.

(vi)

My love and my pet!
Kin to Antrim's earl
And to the Barrys from Aolchoill,
A blade well became you
And a gold-banded beaver,
Boots of Spanish leather,
And suits of finest cloth
You had woven abroad.

(vii)

My deepest darling!
I knew nothing of your killing
Until your horse came straggling,
Her reins beneath her trailing
And your blood upon her withers
Back to the figured saddle
Where you'd sit or stand, daredevil.
My first stride cleared the doorstep,
My second flew through the gateposts,
My third step found your stirrup.

(viii)

My wrought hands beating,
I set your mare careering
As fast as ever I've ridden,
To where I found you deathly still
Beside a stunted whin-bush,
Without pope, without bishop,
Without clergy, without priesthood
To read over you from scripture,
Just a woman, old and wizened,
Who spread her cloak to ease you,
And the blood on you still streaming;
Nor did I stop to clean it,
But palmed it up to drink it.

Translated from Irish by Paddy Bushe

Overleaf: Ladies View, Killarney.

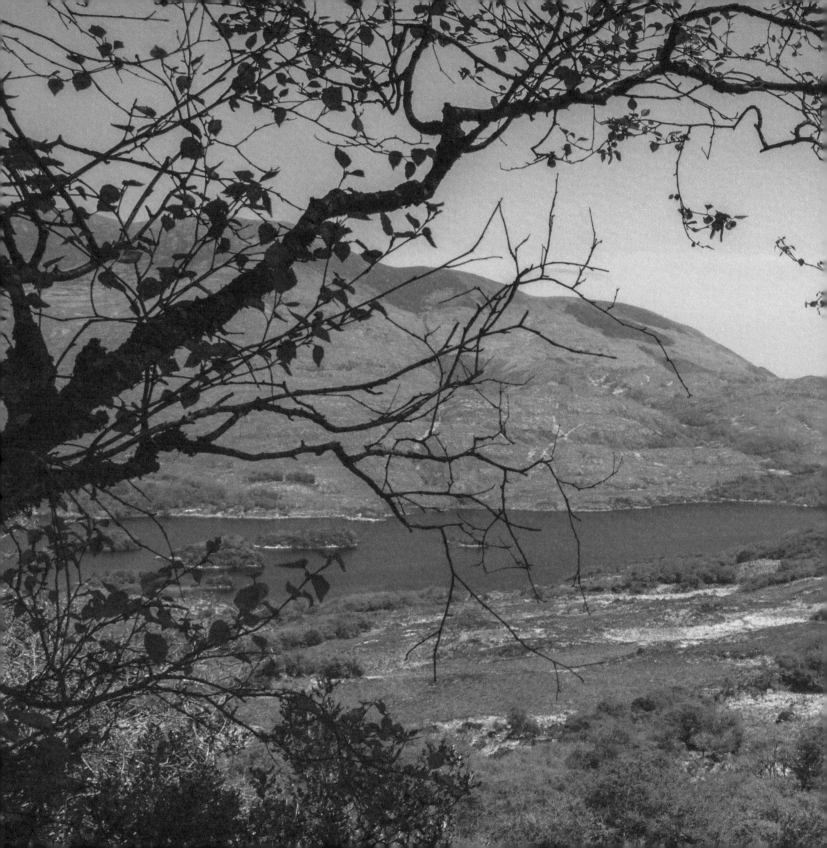

Lament for lost shelter after a storm. Mrs Winnie McDonagh, Ladies Walk, Ballyduff, Co. Kerry.

Eugene O'Connell

THE KEENER

Nora Singleton lost the run of herself
After her husband died in a horse fall,
Turning up unannounced at the funeral
Of a complete stranger she'd cradle
The head of the corpse in her breast,
Launch into this lament that people had
Forgotten until it came alive in her mouth.
The story of a woman putting her lips
To her dying husband's wound and drinking
Before the blood flowed on to the ground.
So vivid a tale that people could imagine
Themselves being there, being astounded
At the words coming out of the mouth
Of the woman with the wine red lips.

Back window of the house of Sliabh
Luachra musical genius, Patrick O'Keeffe
(1887–1963), Glounthane, Cordal.

Michael Hartnett

DEATH OF AN IRISHWOMAN

Ignorant, in the sense
she ate monotonous food
and thought the world was flat,
and pagan, in the sense
she knew the things that moved
at night were neither dogs nor cats
but *púcas* and darkfaced men,
she nevertheless had fierce pride.
But sentenced in the end
to eat thin diminishing porridge
in a stone-cold kitchen
she clenched her brittle hands
around a world
she could not understand.
I loved her from the day she died.
She was a summer dance at the crossroads.
She was a card game where a nose was broken.
She was a song that nobody sings.
She was a house ransacked by soldiers.
She was a language seldom spoken.
She was a child's purse, full of useless things.

púcas: pookas

Life abounds around a dead tree in the Cashen.

Bernard O'Donoghue

THE FOOL IN THE GRAVEYARD

When we die, we help each other out
Better than usual.

This was his big day, and he was glad
His Dad was dead, because everyone,
However important or usually
Unfriendly, came up to him and
Solemnly shook his new leather glove
And said 'I'm sorry for your trouble'.
No trouble at all. All these people
Who normally made fun of him
And said, 'What's your name, Dan?'
And laughed when he said 'Dan' (wasn't
That right and polite?), were nice as pie
Today. He'd missed him going to bed
But they'd given him a pound and
And apple and told him a joke.

That made him laugh a bit.
Coming down the aisle, he'd been
At the front with the coffin on
His shoulder, and everyone
Without exception looked straight
At him, some of them nodding gravely
Or mouthing 'How's Dan', and even
Crying, some of them. He'd tried
To smile and nod back, anxious
To encourage kindness. Maybe
They'd always be nice now, remembering

How he'd carried the coffin. Outside
It was very cold, but he had on
The Crombie coat his Dad had bought.

The earth was always yellower
Here than anywhere else, heaped
Next to the grave with its very
Straight sides. How did they dig
The sides so straight? The priest
Led the prayers, and he knew most
Of the answers. Things were looking up.
Today he was like the main actor
In the village play, or the footballer
Who took the frees, or the priest
On the altar. Every eye
Fixed on him! It was like being loved
And he'd always wondered what that was like.
It wasn't embarrassing at all.

One of the great surviving pubs of Munster. H. M. Grindel of Ballyhooly, Co. Cork.

Greg Delanty

TIE

Without asking, you borrowed your father's black tie,
sure that he had another black tie to wear
should some acquaintance or relation die.
But had he? He should be here somewhere.
But where? Could he be at home on this dark day,
ransacking drawer after drawer for a funeral tie?
Yes, that must be what has kept him away.
Though you are sure you saw him, tieless,
smiling over at you, before you lost him again
among the keening cortege. Leaving you clueless
to his whereabouts, till earth, splattering a coffin
(or was it the wind ululating in each prayer?),
informed you that you can never give your father
back his black tie, though you'll find him everywhere.

Leanne O'Sullivan

LAST RITES

There was no blood. When I ran
to my grandmother's bedroom
where she was dying in her bed
I had expected a sign of murder,
but her heart could not ignite the blood,
the valves like oars had tired.
Her mouth and eyes were opening
and closing like gills. I sat her up
in the bed and leaned her against
my shoulder, heavy like a wet towel.
Almost asleep under the last heat
of her body, she could not hear
all the hearts in the house beating
like wings. When her eyes jerked open
she cried out, *Am I going to die?*
She was three-quarters deaf, and I loved
that I was one-quarter of this woman,
my father had swum in her and I floated
in some chamber of her pure body, utterly alive.
I loved that there was still a portion
of my grandmother vital and listening.
I held her ear to my mouth and spoke
To the fraction of her that could decipher.

I said, *You are never leaving.* I felt
I spoke to her outside the realm of sound,
as if we were making a communion
in the woods and saw, in a clearing,
branches parting and light breaking
in the dark, fragile as the drops of sweat
on her chest as I leant down to kiss her heart.
I would have believed she could hear me,
but when the priest walked in he took
her hand as it went limp, a fallen leaf,
and she did not hear the prayers. You're there
with your crook and staff, Grandmother,
with these you've given me courage.
And to the ears of some deaf Angel
I whisper, *Amen*, my love.

A pair of horses grazing against a backdrop of pure beauty in Glengariff, Co. Cork.

Theo Dorgan

THE ANGEL OF DAYS TO EUGENE LAMBERT

And what did you do on earth?

I did my work.

I went at it all wide-eyed,
with a steady heart.
I reared strong sons and daughters,
I mastered my craft.

And what was the best of it?

Loving, and being loved.

I pity God, who never walked home by night
or drove the length of Ireland in the rain,
or came in from the workshop
with a new story, sawdust and glue on his hands,
to Mai in the full house – such a welcome I had!

And what would you have changed?

Nothing. Not one blessed thing.

I loved my world –
the hush when a story started up,
watching my hands at work,
children, their laughter.
I never minded the black days –
storms will blow over, it's their nature.

And what will you do now?

It's been a long road, I might have a rest.
I might do a small bit of work, to keep my hand in.

i.m. Eugene Lambert 1928–2010

Seán Ó Ríordáin

Translated from Irish by Gabriel Fitzmaurice

MY MOTHER'S BURIAL

June sun in the orchard
 And a silken rustling in the fading day,
An infernal bee humming
 Like a screamtearing of the evening's veil.

I was reading an old, soiled letter,
 And every word-drink I imbibed
Thorned my heart with bitter pain;
 At every single word I read, I cried.

I remembered then the hand that wrote the letter,
 A hand recognisable as a face,
A hand that bestowed the mildness of an old Bible,
 A hand that was like balsam to my pain.

And then the June fell over into winter
 And the orchard became a white cemetery by a stream,
And amid the silent whiteness all around me
 Through the snow I could hear the black hole scream.

The brightness of a girl on the day of her First Communion,
 The brightness of the host on Sunday on the altar of God,
The brightness of milk flowing freely from the breasts,
 When they buried my mother, the brightness of the sod.

While my mind was scourging itself with trying
 To taste my mother's burial, whole, complete,
Through the white silence flew so gently
 A robin, unflustered, without fear.

She remained above the grave as if knowing
 That the reason for her coming was concealed
To all but the one lying waiting in the coffin
 And I was jealous of this strange intimacy.

The air of Heaven descended on that grave there,
 There was a terrible, holy mirth about that robin,
I was cut off from the mystery like a layman,
 The grave was far away though I was beside the coffin.

My lustful soul was cleansed with sweetest sorrow,
 On my heart there fell a snow of purity,
In the heart that was made upright I will bury
 The memory of her who carried me for three seasons.

The strong men began with their rude shovels
 And roughly swept the earth into her grave;
I looked the other way, a neighbour was brushing his knees clean,
 I looked at the priest and saw worldliness in his face.

June sun in the orchard
 And a silken rustling in the fading day,
An infernal bee humming
 Like a screamtearing of the evening's veil.

I am writing small, uneven verses,
 I would like to catch a robin's tail,
I would like to banish the knee-brushing spirit,
 To journey sadly to the end of day.

Opposite: A point of solace. The spire of the Church of Saints Stephen and John, Castleisland.

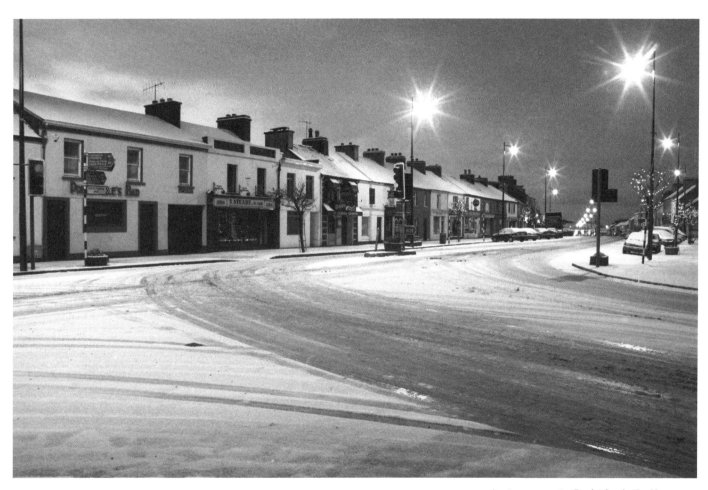

A winter scene in Castleisland, Co. Kerry.

Jo Slade

WINTER 1963

He looked so beautiful
skating the lake
making a huge figure eight.

It might have been
this time of year, late January.
I remember white
as far as my eyes could see
from the back of our old
black Austin Cambridge.

I can hear my mother say,
'Peter it's been snowing all day,
do you think we should risk it?'

We went anyway,
his skates packed in the boot
and a makeshift sleigh.

I remember coloured lights
flickering and everyone laughing.
Lough Gur glistened
in the winter gloom.

Then he glided onto the ice –
my Da like a ballet dancer
and Mam giggled
as his dark form looped
and veered away.

He was gone, lost
in a white world as it was then,
until the moon rose
and made him visible again.

Seán Ó Tuama

CHRISTY RING

He aimed at the impossible
each Sunday on the pitch;
sometimes he succeeded.

Down on one knee,
trapped in a corner of the field,
when his prechristian electronic eye
lit up in combat,
and the ball, a missile,
sped from him straight above the bar,
the air shook in awe.

When a driving lunge
brought him clear beyond
the ruck of men,
and the ball, propelled,
self-destructed in the net
to smithereens of light,
our cheering became a battle cry.

In one moment of raw frenzy
as his playing days ran out,
he summoned Cú Chulainn
to aid him on the pitch:
his trunk swelled up,
in sight of thousands,
one eye bulged
and danced, demented,
through clash and crash
hue and cry
men were toppled
hot blood spurted
and as he rammed in
three lethal goals
all the gods of ancient Ireland
lent his hurley a guiding hand.

Looking at his corpse laid out,
the day of his untimely death,
a woman said:
'It would be a sin to bury such a man'.

I have not managed yet to bury Christy Ring.
Sometimes I imagine him
being venerated
in the care of the great god, Aengus,
on a slab at Newgrange
and at each winter solstice
for just one half an hour
a ray of sunshine
lighting up his countenance.

But no friend of his could think
of laying Christy Ring eternally to rest
locked in with ancient miracles –
for oh the miracles of the living flesh
we saw when his countenance lit up
Winter days and Summer days
Sundays in and Sundays out,
on the playing pitch.

Translated from Irish by the author

Christy Ring (1920–1979), Cloyne, Glen
Rovers and Cork hurling hero.

Overleaf: A soft day as mist sweeps in over
the Burren as seen from the Corkscrew Hill.

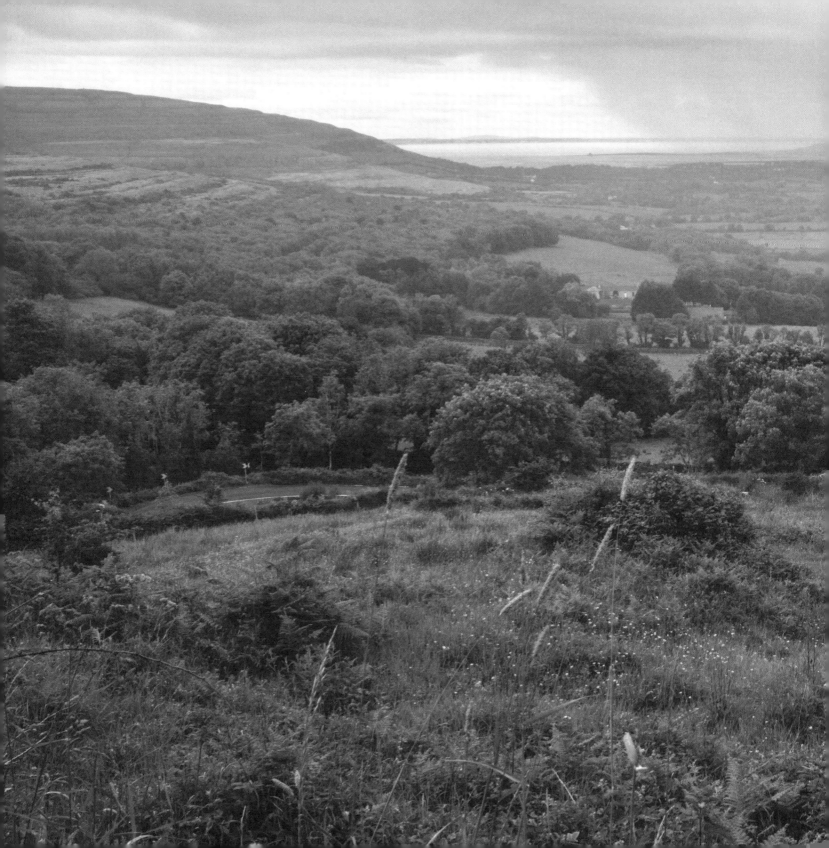

Taking in the beauty of Ladies View in Killarney.

Bernard O'Donoghue

MUNSTER FINAL

In memory of Tom Creedon, died 21 August 1983

The jarveys to the west side of the town
Are robbers to a man, and if you tried
To drive through The Gap, they'd nearly strike you
With their whips. So we parked facing for home
And joined the long troop down the meadowsweet
And woodbine-scented road into the town.
By blue Killarney's lakes and glens to see
The white posts on the green! To be deafened
By the muzzy megaphone of Jimmy Shand
And the testy bray to keep the gangways clear.

As for Tom Creedon, I can see him still,
His back arching casually to field and clear.
'Glory Macroom! Good boy, Tom Creedon!'
We'd be back next year to try our luck in Cork.

We will be back next year, roaring ourselves
Hoarse, praying for better luck. After first Mass
We'll get there early; that's our only hope.
Keep clear of the carparks so we're not hemmed in,
And we'll be home, God willing, for the cows.

Three and a half barrels outside Coolahan's Bar in Tarbert, Co. Kerry.

JUST MY LUCK I'M NOT PIG-IGNORANT

Just my luck I'm not pig-ignorant
Though it's bad to be a boor
Now that I have to go out among
This miserable shower.

A pity I'm not a stutterer,
Good people, among you
For that would suit you better,
You thick, ignorant crew.

If I found a man to swap, I'd trade
Him verses that would cheer –
As good a cloak as would come, he'd find,
Between him and despair.

Since a man is less respected
For his talent than his suit,
I regret that what I've spent on art
I haven't now in cloth.

Since happy the words and deeds that show no hint,
On boorish tongues, of music, metre, clarity,
I regret the time I've wasted grappling with hard print
Since my prime, that I didn't spend it on vulgarity.

Translated from Irish by Gabriel Fitzmaurice

Michael Hartnett

ON THOSE WHO STOLE OUR CAT, A CURSE

On those who stole our cat, a curse:
may they always have an empty purse
and need a doctor and a nurse
 prematurely;
may their next car be a big, black hearse –
 oh may it, surely!

May all their kids come down with mange,
their eldest daughter start acting strange,
and the wife start riding the range
 (and I don't mean the Aga);
when she begins to go through the change
 may she go gaga.

And may the husband lose his job
and have great trouble with his knob
and the son turn out a yob
 and smash the place up;
may he give his da a belt in the gob
 and mess his face up!

And may the granny end up in jail
for opening her neighbours' mail,
may all that clan moan, weep and wail,
 turn grey and wizened
on the day she doesn't get bail
 but Mountjoy Prison!

Oh may their daughter get up the pole,
and their drunken uncle lose his dole,
for our poor cat one day they stole –
 may they rue it!
And if there is a black hell-hole
 may they go through it!

Unfriendly loan-sharks at their door
as they beg for one week more;
may the seven curses of Inchicore
 rot and blight 'em!
May all their enemies settle the score
 and kick the shite of 'em!

I wish rabies on all their pets,
I wish them a flock of bastard gets,
I wish 'em a load of unpayable debts,
 TV inspectors –
to show 'em a poet never forgets
 his malefactors.

May rats and mice them ever hound,
may half of them be of mind unsound,
may their house burn down to the ground
 and no insurance;
may drugs and thugs their lives surround
 beyond endurance!

May God forgive the heartless thief
who caused our household so much grief;
if you think I'm harsh, sigh with relief –
 I haven't even started.
I can do worse. I am, in brief,
 yours truly, Michael Hartnett.

Cat napping 'neath nasturtium.

103

A shop out of season on Beale Strand, Co. Kerry.

A house with a story. The Shepherd's Inn at Looscanaugh on the Killarney to Kenmare Road.

Michael Davitt

THE MOB HAVE SURROUNDED THE HOUSE, MAMMY

The mob have surrounded the house, Mammy,
The mob have surrounded our place,
The mob have surrounded the house, Mammy,
The mob have surrounded our place.
They're wearing white habits, Mammy, gloves and a mask on each face.

They've The Daily Scoop in their hands, Mammy,
Cans of petrol and sharp, sharp knives,
They've The Daily Scoop in their hands, Mammy,
Cans of petrol and sharp, sharp knives.
They don't know what for, Mammy, but we'll pay for it with our lives.

They burned a mosque to the ground last night, Mammy,
A library and two churches hereabouts,
They burned a mosque to the ground last night, Mammy,
A library and two churches hereabouts.
They stabbed a tinker woman and cut the tongue from her mouth.

The mob have surrounded the house, Mammy,

The mob have surrounded our place,

The mob have surrounded the house, Mammy,

The mob have surrounded our place.

They're wearing white habits, Mammy, gloves and a mask on each face.

The mob are burning the house, Mammy,

The mob are burning our place,

The mob are burning the house, Mammy,

The mob are burning our place.

They can burn the whole world down, Mammy, but they can't burn their hearts' grimace.

Translated from Irish by Gabriel Fitzmaurice

Rear entrance to Finucane's Bar in Ballylongford, Co. Kerry.

Áine Ní Ghlinn

PÁIDÍN IN LONDON

Páidín

He doesn't call himself
Páidín or Pat
or even Paddy
now that he's
in London
but Patrick
Patrick Conneely
and he didn't cast
as much as a glance
over his shoulder
the time he heard
a woman's voice
calling 'Páidín'
that morning
as he stood
backside to the wind
at the hiring fair
in Cricklewood
'I'm not Páidín'
he told himself
'I'm Patrick
Patrick Conneely'
He craned his neck
to loosen the tie
he wasn't wearing
Like an old cow
chewing the cud

he tested the words
on his tongue
'Patrick
Patrick Conneely'

Cricklewood 6.00 a.m.

Everyone has his own way of seeing things
and that's how it is with Páidín Ó Conaola
or – excuse me – Patrick Conneely
'I'm between jobs' he says
'You know yourself and seeing as
I'd nothing else to do I thought
I might as well drop down here
and see who I'd meet – someone
from home maybe – You know yourself
No No – Plenty work and grand for money
Just – Well, you know yourself'

Letter From Home

The postman comes at seven
Páidín gets up at five to
and listens for the creak of the gate
The letters fall like autumn leaves
Páidín catches them before they hit the floor
All part of the trick
The morning ritual
Páidín says he likes
to sort the letters
for the other tenants
The bed is cold when he goes
back upstairs

Páidín's Liver

In spite of the doctor's advice
Páidín won't give up the drink
What's the point in purging your liver
while your heart is bursting
with loneliness?

Phonecall Home

Yeah, sure, Mam,
Great altogether.
I have a flat
two rooms,
they're grand and cosy
Central heating an' all
No, I've no phone yet
But I'll see you
come Christmas
Yeah, Christmas
with the help of God …

He puts down the phone.
Slings his duffle bag
over his shoulder
his sleeping bag
under his oxter
and goes walking back
to his cardboard box
behind Waterloo Station

Another Day Down …

Páidín stands at the counter
He laughs at a dirty joke
he tells himself
murmurs soft obscenities
at a woman who walks away

He makes a fist of his right hand
He fights with the air
getting the upper hand
on that big Englishman
who called him a Paddy this morning

His left hand pumps in the drink
The beer here isn't the same
as the good stuff you'd get at home
but still an' all –
'Another pint, my good man'

At the end of the night
Páidín says goodbye
to the barman
to strangers
to the friends of his imagination

He walks around the corner
urinates
against the wall
and throws up
the evening's pints

Then singing *Amhrán na bhFiann*
He walks back to his tiny room
He kisses his mother's photo
takes off his boots
and sleeps

Saturday Spree

On Saturday Páidín buys a day ticket
Three pounds forty for the freedom of the city
The heat of the bodies excites him
He holds imaginary conversations
with total strangers who move away
as soon as his lips begin to move
Páidín goes from train to train
north south south north
'I went to Wembley yesterday, Mam,
where they play the snooker and the soccer'
he says in his weekly letter home
'Last week I was in Clapham'
He doesn't tell them he never left the station

Páidín's Garden

Páidín sows some seed
in a little box
on the window sill
of his sixth floor flat.
He loves the feel
of the clay
under his fingernails.

Homecoming

Páidín drove home for Christmas
in a car whose front bumper would be
touching the front door of the church
while the back wheels were
still coming in the gate
He kept the documents
from the hiring agency
hidden deep down
in the inside pocket
of his Sunday jacket

Translated from Irish by Pádraig Ó Snodaigh

The road to Clonmel: Castleisland trainer, Michael Murphy,
preparing his charges for Clonmel.

Looking out for lost souls at sea from Fenit Pier by Connolly's Sculptors, Kilbaha.

The spit of the father. Family dining in Moanmore, Castleisland.

Seán Ó Ríordáin

SWITCH

'Come over here,' said Turnbull, 'till you see the sorrow
 in the horse's eyes.
Had you such heavy hooves as these for feet there would be sorrow
 in your eyes too.'

And it was plain to me, that he'd realised the sorrow
 in the horse's eyes so well,
So deeply had he contemplated it, that he was steeped
 in the horse's mind.

I looked at the horse, that I might see the sorrow
 standing in its eyes,
And saw instead the eyes of Turnbull looking at me
 from the horse's head.

I looked at Turnbull, then I took a second look,
 and saw looming from his face
The over-big eyes that were dumb with sorrow –
 the horse's eyes.

Translated from Irish by Ciaran Carson

Gateway to a famine plot in Castleisland.

John McAuliffe

HOUSE AT NIGHT

Because there's no one else around
you like the house at night.
Silent phones, a blank screen,
cherry blossom edging
the extra hour. Nothing to do.
No one's going to call.

 Spring,
a forgotten pocket you dip into,
turns up a late ray of light
across your mouth
and neck.
House at night, last
a little longer!

The twin spires of St Mary's Parish
Church (left) and St John's Theatre (right)
overlooking Listowel's William Street.

John B. Keane

THE STREET

I love the flags that pave the walk.
I love the mud between,
The funny figures drawn in chalk.
I love to hear the sound
Of drays upon their round,
Of horses and their clock-like walk.
I love to watch the corner-people gawk
And hear what underlies their idle talk.

I love to hear the music of the rain.
I love to hear the sound
Of yellow waters flushing in the main.
I love the breaks between
When little boys begin
To sail their paper galleons in the drain.
Grey clouds sail west and silver-tips remain.
The street, thank God, is bright and clean again.

Here, within a single little street,
Is everything that is,
Of pomp and blessed poverty made sweet
And all that is of love
Of man and God above.
Of happiness and sorrow and conceit,
Of tragedy and death and bitter-sweet,
Of hope, despair, illusion and defeat.

A golden mellow peace forever clings
Along the little street.
There are so very many lasting things
Beyond the wall of strife
In our beleaguered life.
There are so many lovely songs to sing
Of God and His eternal love that rings
Of simple people and of simple things.

Collectors' clutter: Generations of memories in Finucane's Bar on Ballylongford's Quay Street.

Michael Hartnett

from MAIDEN STREET BALLAD

1

Come all you young poets and listen to me,
and I hope that my words put a flea in your ears;
a poet's not a poet until the day he
 can write a few songs for his people.
You can write about roses in ivory towers
and dazzle the critics with your mental powers,
but unless from your high horse you cannot come down
 you're guilty of poetic treason.

2

You can write about writers in verse that is free
and rob all the stories from our history;
you can rhyme about China and philosophy –
 but who gives a shite for your blather?
Your friends are your friends, for better or worse,
to speak to them straight put rhyme in your verse;
if the critics don't like it they can all kiss my arse –
 as long as it's read by my father.

3

So relax and I'll tell you what I'm going to do,
take a sup from your drink, start unlacing your shoes;
you'll be in a bad way when I'm finished with you,
 and ringing up doctors and nurses.
My song's not so long – it's about my own life,
and the things that I saw as a man and a child –
but it won't keep you up too late in the night
 for it only has fifty-three verses! …

8

Now before you get settled, take a warning from me
for I'll tell you some things that you won't like to hear –
we were hungry and poor down in Lower Maiden Street,
 a fact I will swear on the Bible.
There were shopkeepers then, quite safe and secure –
seven Masses a week and then shit on the poor;
ye know who I mean, of that I am sure,
 and if they like they can sue me for libel.

9

They say you should never speak ill of the dead
but a poet must say what is inside his head;
let drapers and bottlers now tremble in dread:
 they no longer can pay men slave wages.
Let hucksters and grocers and traders join in
for they all bear the guilt of a terrible sin:
they thought themselves better than their fellow-men –
 now the nettles grow thick on their gravestones …

46

I have told ye no big lies, and most of the truth –
not hidden the hardships of the days of our youth
when we wore lumber jackets and had voucher boots
 and were raggy and snot-nosed and needy.
So now – there you have it, the long and the short –
and there may be some people that I have forgot;
if you're not in this ballad, be thankful you're not,
 but anyway, buy it and read it.

47

So now to conclude and to finish my song:
it wasn't composed to do decent men wrong;
if I had known it would go on so long
 I'd have finished before I got started.
And in times to come if you want to dip
back into the past, through these pages flip
and, if you enjoy it, raise a glass to your lips
 and drink to the soul of Mike Hartnett!

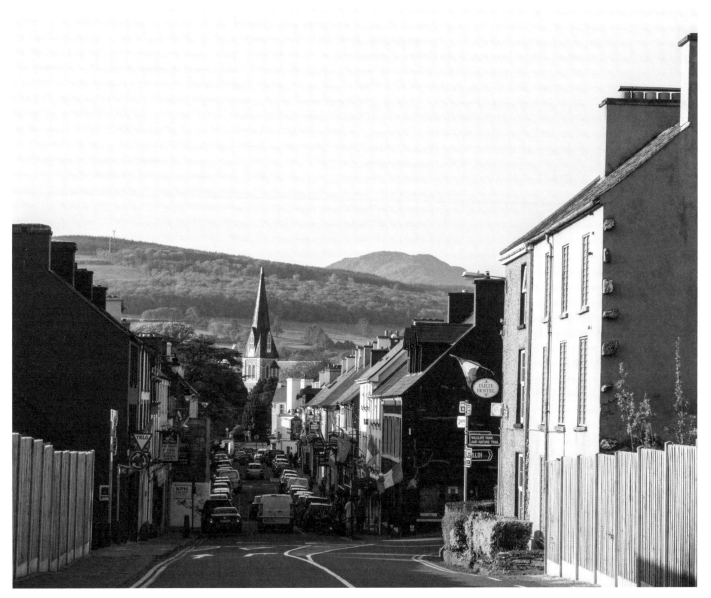

Henry Street playing its daily part in the planned town of Kenmare.

Overleaf: Bridge over the River Tar at Clogheen, Co. Tipperary with the Knockmealdown Mountains as an ever-changing backdrop.

Desmond O'Grady

TIPPERARY

Tipperary: from the Irish Tiobraidarann: the fountain of perception, or enlightenment, intelligence

It's a long way to Tipperary
it's a long way to go – and devious.
It's a torture of twists, about-turns,
disillusions, disappointments.
The way to Tipperary appears
perennially dark with only
occasional twilights.

If you decide to go to Tipperary
set out while you're young, plucky;
at that age when you're bright-eyed with visions
of radiant horizons of revelation and achievement
and you know nothing of twilights or the dark;
that age when all creation, all life shines clear
as spring sunlight, bright as light-catching gold.

When you set out you must go alone.
There are no maps of the way to Tipperary.
Your only compass is your own heart. Trust that!

Some see their Tipperary clearly from the start;
see it's a long road, full of daily pitfalls;
a labyrinth of curious sidestreets, inviting
guesthouses; giddy with temptations
of those bogey people's trinket stalls'
hokeypokey – daily thieves of eternal energy –
easy come, easy go, you've sold your soul,
you've no more choice. They sell bedlam!

Explore all those sidestreets
enjoy your chosen resthouses
fool them with a few trinkets to learn
something of the way to Tipperary.

The long way to Tipperary's darkened
with the shadows of all those
who never got there anyway;
those who settled for some resthouse,
some casual trinket thief of time.
Don't let those shadows,
mumbling in their own gloom,
deter or deviate you.
Hold to your main road. Keep going!

Once you've decided to go to Tipperary
you'll realize you no longer belong to yourself
but must keep Tipperary in your sights daily –
although you can't see it. Purpose is all.
Without your Tipperary you too are a mere shadow
at those Limerick Junctions of daily resolution.

On the way to Tipperary keep your eye open
for signals of direction, encouragement:
that nod of understanding, comradeship,
a cherishing arm on your pillow. You'll see
beautiful sights on your way to Tipperary:
man's mirage tales, imagination's monuments.
You'll behold the endless vistas, panoramas
of vision. Be curious about them all
for the gracious gifts they will afford you.
Without them you'd live that much the poorer.

It's a long way to Tipperary
and when you get there
nothing awaits you. You'll find no roadsign,
no brassband and welcoming committee
with a banner proclaiming you're in Tipperary
and a medallion to hang around your neck.
You'll find only what you brought with you
in your heart.

Then, what you must do
is make and leave some record
of what your Tipperary means to you –
as witness for all those behind you
on their ways to their own Tipperaries.

It's a long way to Tipperary
but all our hearts lie there.

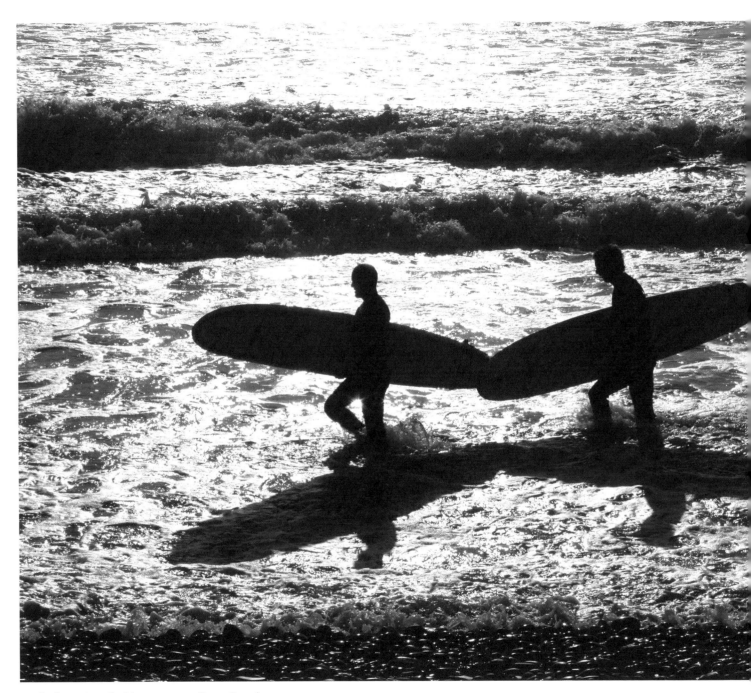

Surfers waiting for bigger waves on Banna Strand.

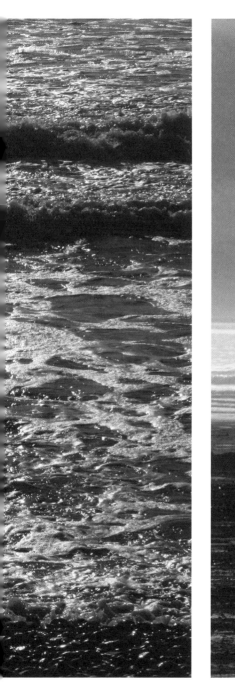
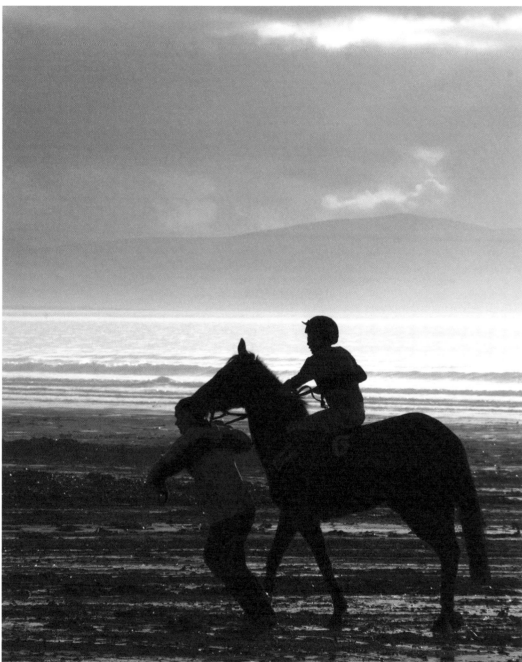

Heading to the starting line: Pony racing on Ballyheigue Beach.

PERMISSIONS

Brendan Kennelly, 'The Gift' and 'The Tippler' from *Familiar Strangers: New & Selected Poems 1960–2004* (Bloodaxe Books, 2004), © Brendan Kennelly; Leanne O'Sullivan, 'Last Rites' from *Waiting for my Clothes* (Bloodaxe Books, 2004), © Leanne O'Sullivan. Liam Ó Muirthile, 'Friendship', translated by Bernard O'Donoghue from *Poems of Repossession* (Bloodaxe in association with Cló Iar-Chonnacht, 2016), © Bernard O'Donoghue. Reproduced by permission of Bloodaxe Books on behalf of the authors.

Dennis O'Driscoll, 'Missing God' from *Exemplary Damages* (Anvil Press, 2002), © Dennis O'Driscoll; Greg Delanty, 'Tie' from *Collected Poems 1986–2006* (Carcanet Press, 2006), © Greg Delanty. Reproduced by permission of Carcanet Press.

Michael Coady, 'Solo' and 'Though There Are Torturers' from *Two for a Woman, Three for a Man* (The Gallery Press, 1980), © Michael Coady. By kind permission of the author and The Gallery Press, Loughcrew, Oldcastle, Co. Meath, Ireland. Seán Dunne, 'Against the Storm' from *Collected* (The Gallery Press, 2005), © Seán Dunne. By kind permission of the Estate of Seán Dunne and The Gallery Press. Michael Hartnett, 'A Farewell to English' and 'Death of an Irishwoman' from *Collected Poems* (The Gallery Press, 2001), 'On Those Who Stole Our Cat, A Curse' and extract from 'Maiden Street Ballad' from *A Book of Strays* (The Gallery Press, 2002), © Michael Hartnett. By kind permission of the Estate of Michael Hartnett c/o The Gallery Press. John McAuliffe, 'House at Night' from *The Way In* (The Gallery Press, 2015), © John McAuliffe. By kind permission of the author and The Gallery Press. Nuala Ní Dhomhnaill (trans. from Irish by Paul Muldoon), 'The Language Issue' from *Pharaoh's Daughter* (The Gallery Press, 1990), © Paul Muldoon and Nuala Ní Dhomhnaill. By kind permission of the author and The Gallery Press. Eiléan Ní Chuilleanáin, 'To Niall Woods and Xenya Ostrovskaia, married in Dublin on 9 September 2009' from *The Sun-fish* (The Gallery Press, 2009), © Eiléan Ní Chuilleanáin. By kind permission of the author and The Gallery Press. Peter Sirr, 'Slipping Into It' from *The Thing Is* (The Gallery Press, 2009), © Peter Sirr. By kind permission of the author and The Gallery Press.

Sigerson Clifford, 'The Ballad of the Tinker's Son' from *Ballads of a Bogman* (Mercier Press, 1986), © The Estate of Sigerson Clifford. Reprinted with kind permission of Mercier Press, Ireland. Gabriel Rosenstock, 'Television', translated by Gabriel Fitzmaurice from *The Rhino's Specs/Spéaclaí an tSrónbheannaigh* (Mercier Press, 2002), © Gabriel Rosenstock & Gabriel Fitzmaurice. Reprinted with kind permission of Mercier Press, Ireland. Brendan Kennelly (trans.), 'The Old Woman of Beare' from *Love of Ireland* (Mercier Press, 1989), © Brendan Kennelly. Reprinted with kind permission of Mercier Press, Ireland. Dáibhí Ó Bruadair, 'Just My Luck I'm Not Pig-Ignorant', translated by Gabriel Fitzmaurice from *Poems from the Irish* (Mercier Press, 2004), © Gabriel Fitzmaurice. Reprinted with kind permission of Mercier Press, Ireland. John B. Keane, 'The Street' from *The Street* (Mercier Press, 2003), © J. B. Keane. Reprinted with kind permission of Mercier Press, Ireland.

Extract from 'The Midnight Court' by Brian Merriman, translated by Frank O'Connor from *The Midnight Court* (The O'Brien Press, 1989), © The Estate of Frank O'Connor. Reproduced by kind permission of The O'Brien Press.

Pádraig J. Daly, 'God in Winter' from *God in Winter* (Dedalus Press, 2015), © Pádraig J. Daly. Reproduced by kind permission of Dedalus Press. Eibhlín Dhubh Ní Chonaill, extract from 'The Howl for Art Ó Laoghaire', translated by Paddy Bushe from *My Lord Buddha of Carraig Éanna* (Dedalus Press, 2012), © Paddy Bushe. Reproduced by kind permission of Dedalus Press. Theo Dorgan, 'The Angel of Days to Eugene Lambert' from *Nine Bright Shiners* (Dedalus Press, 2014), © Theo Dorgan. Reproduced by kind permission of Dedalus Press. Áine Ní Ghlinn, 'Páidín in London' from *Unshed Tears/Deora Nár Caoineadh* (Dedalus Press, 1996), © Áine Ní Ghlinn. Reproduced by kind permission of Dedalus Press.

Jo Slade, 'Winter 1963' from *The Painter's House* (Salmon Poetry, 2013), © Jo Slade. Reproduced by kind permission of Salmon Poetry. Desmond O'Grady, 'Tipperary' from *Tipperary* (Salmon Poetry, 1991), © Desmond O'Grady. Reproduced by kind permission of Salmon Poetry.